Drawing
Workshop

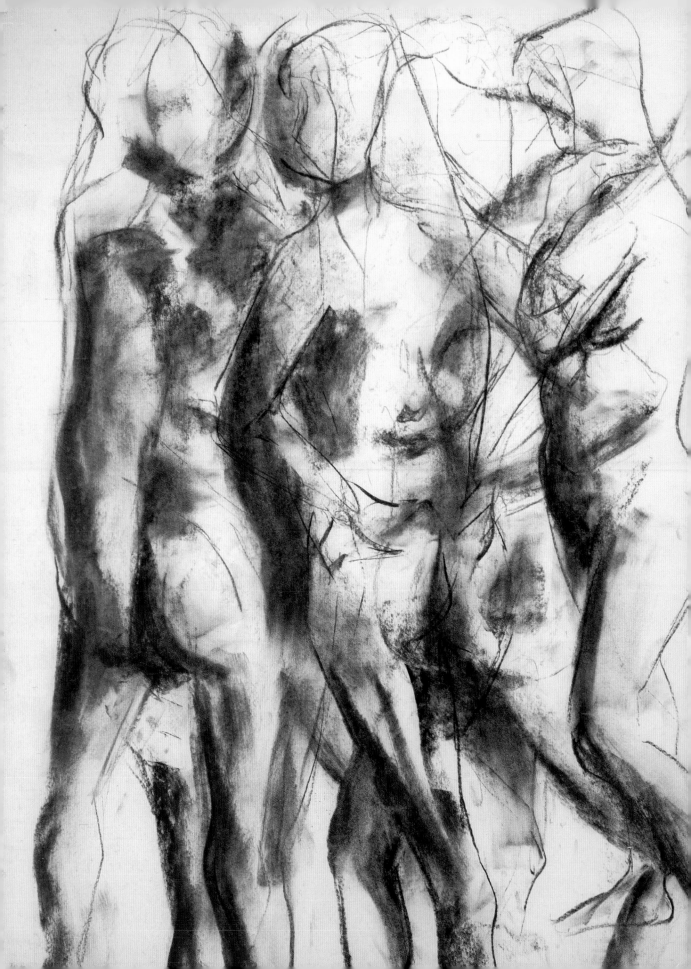

Drawing
Workshop

Lucy Watson

LONDON, NEW YORK, MELBOURNE,
MUNICH, DELHI

Editor Kathryn Wilkinson
Project Art Editor Anna Plucinska
Senior Editor Angela Wilkes
DTP Designer Adam Walker

Managing Editor Julie Oughton
Managing Art Editor Heather McCarry
Production Controller Wendy Penn
US Editor Jenny Siklós

Contributing Editor Anna Fischel
Contributing Artist Lynne Misiewicz
Photographer Andy Crawford

First American Edition, 2006

Published in the United States by
DK Publishing, Inc., 375 Hudson Street,
New York, New York 10014

06 07 08 09 10 10 9 8 7 6 5 4 3 2 1

A Cataloging-in-Publication record for this book is
available from the Library of Congress.

ISBN-13: 978-0-7566-1938-1

ISBN-10: 0-7566-1938-6

DK books are available at special discounts for bulk
purchases for sales promotions, premiums, fund-raising,
or educational use. For details, contact: DK Publishing
Special Markets, 375 Hudson Street, New York, NY 10014
or SpecialSales@dk.com

Printed and bound in China by
Hung Hing Offset Printing Company Ltd

Discover more at
www.dk.com

Contents

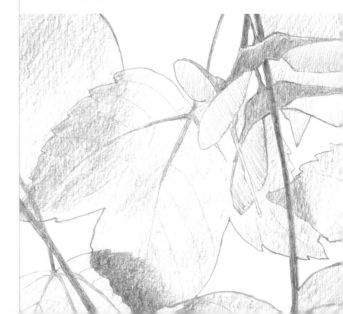

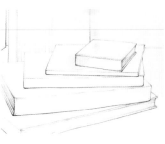

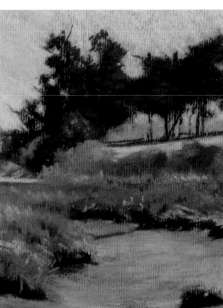
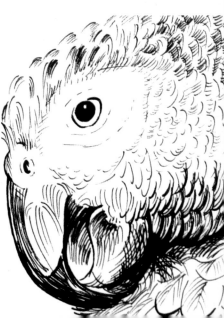

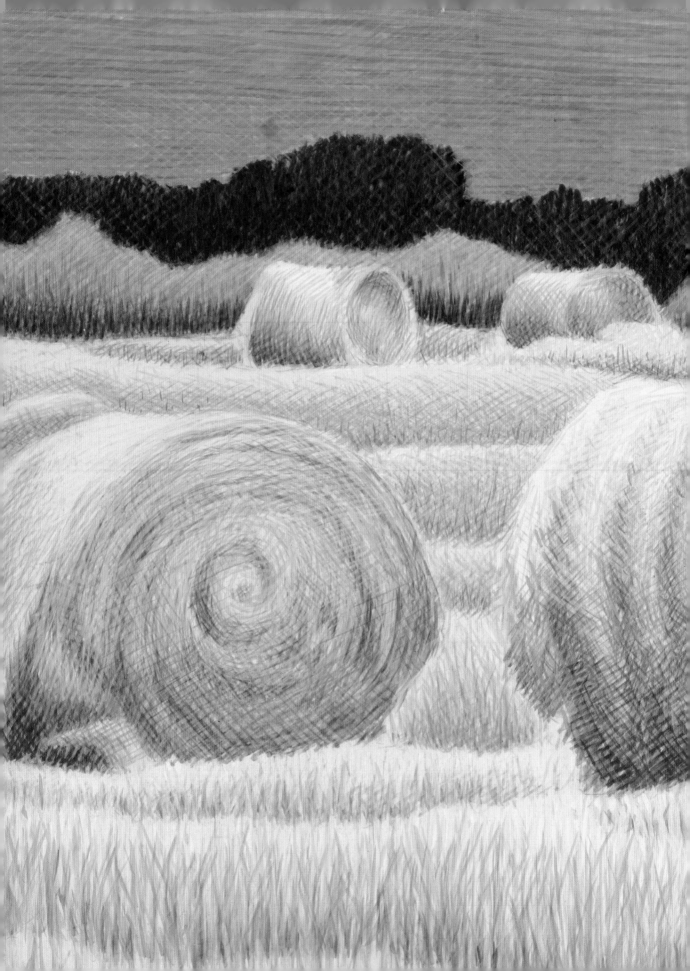

Introduction

Children find the external world utterly absorbing but, as time creeps on, your brain learns to edit out most of what you see, homing in only on what is important to find your way, recognize a face, or put your shoes on. Drawing takes the opposite approach. Half the battle is close observation. It can make you see afresh, marvel at the most familiar sights, notice detail you've overlooked for years, and glory in the natural or man-made world.

Today's perspective on drawing

Because the brain rapidly scans any given scene, it tends to override the effects of perspective. It knows that a bus in the distance is the same size as the one you're getting on. It ignores all that boring expanse at the top of the head and just focuses on the features. It is aware that horizontal lines of buildings are level and don't tilt. When it comes to drawing, you have to quell that logical voice and believe your eyes. If a distant bus looks smaller, draw it smaller. If your measurements tell you the eyes are only halfway up the head, position them there—most beginners place the eyes far too high. If the horizontals of a building

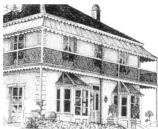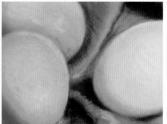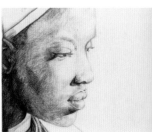

appear to slope, copy the lines as you see them. These simple rules of perspective are what makes a drawing look right, and you can learn them in tandem with gaining fluency with pencil strokes.

Ever since Cézanne took a multiple viewpoint on a bowl of fruit toward the end of the 19th century, the merit of these rules of realistic drawing, which had held good in Western art since the Renaissance, has been in question. Many artists have no wish to pretend paper is three-dimensional, and would rather emphasize its patternmaking qualities. They don't want the illusion of solidity and distance. Fine, but

you have to know the rules before you can break them so that you are in control. Once you can make a recognizable portrait and draw a foreshortened figure, you can elongate and distort the human form all you like for dramatic effect. When you can draw a path that winds enticingly through a swathe of trees to the distant hills, you can deliberately flatten a landscape.

Keeping a sketchbook

Just as with learning to play the piano, regular practice brings about noticeable improvements. Keep a sketchbook diary and draw the events of your day.

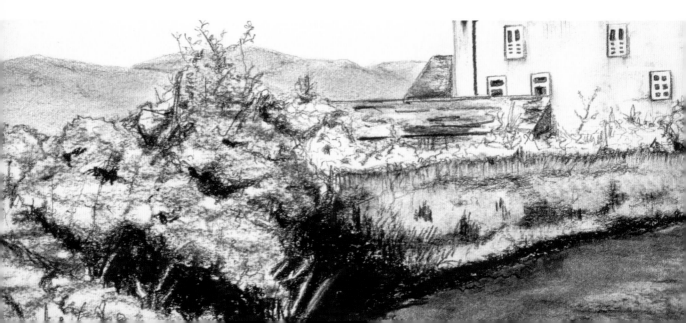

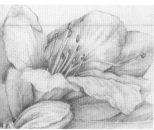 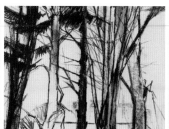 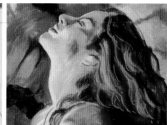 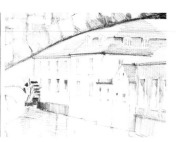

Splurge out your feelings and thoughts in a personal vision. Try out compositions and thumbnail sketches, doodle, and copy whatever catches your eye. No one else needs to see your efforts.

Drawing offers you spontaneity and freedom. Don't be afraid to make mistakes or become too dependent on erasers. Accept your limitations and paradoxically your horizons will expand—literally. Use larger paper as you gain confidence. Try out the wealth of drawing media available and introduce color to your repertoire. Drawing is an art in its own right, but it is also an essential foundation to painting.

The aim of this book is to show you the difference between looking normally and looking for drawing. Professional artists then teach you how to put what you see down on paper, whether you are working in pencil, charcoal, pen, colored pencil, or pastel. Once you understand your materials and have practiced the techniques, the projects help you apply your knowledge and skills to create finished pictures. Now you can enjoy drawing, tossing aside the frustration of sketches that don't translate what is in your mind's eye onto paper. Draw as much, and with as much relish, as you did when you were three years old.

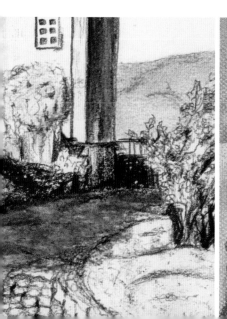 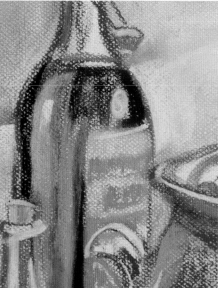 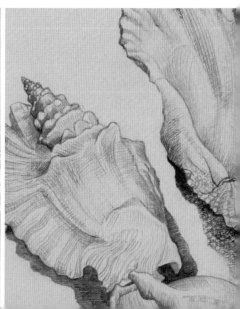

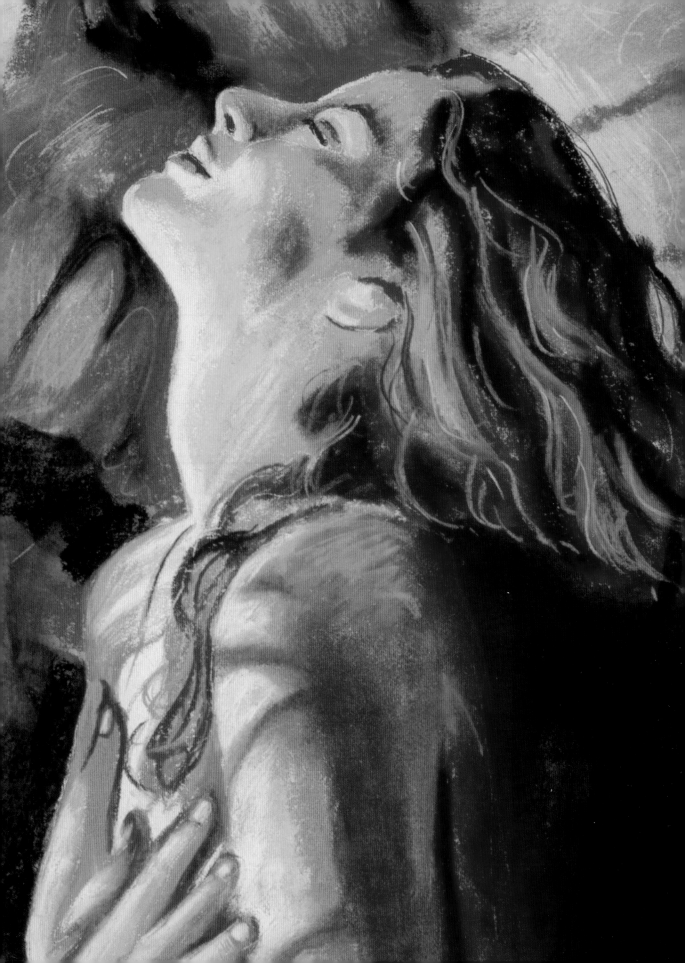

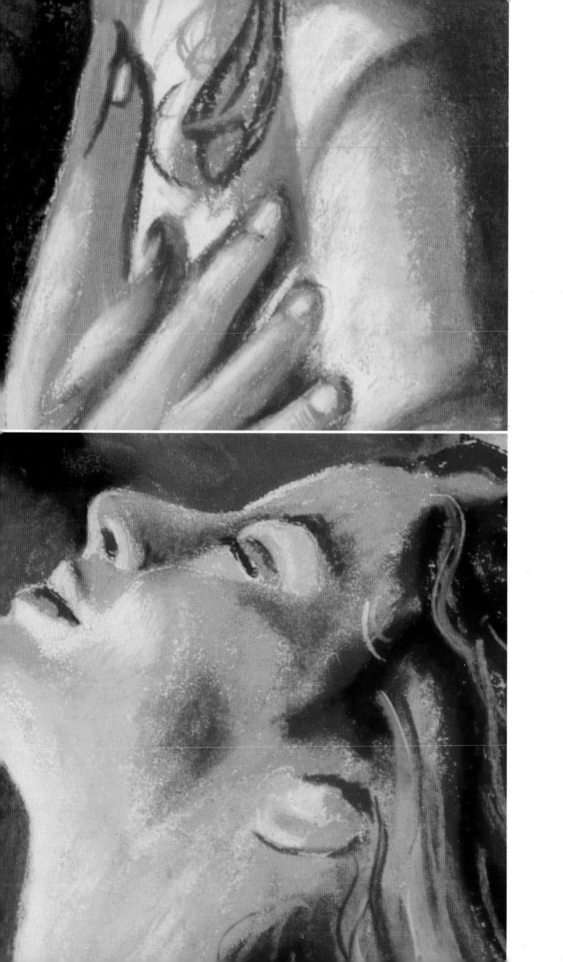

Drawing with pencils

Pencils are ideal for drawing. They are a versatile medium for building up varying degrees of line and tone, are simple to carry around, and can be easily rubbed out. When you take up your pencil, relax your grip, and try working with your hand higher up the shaft for bold, sketchy lines: drawing is not the same as writing, and your sketches will look cramped if you clench your pencil tightly near the lead.

GRAPHITE PENCILS

Available in a variety of grades, pencils range from 8H or 9H, the hardest, to 8B or 9B, the softest pencils for shading. Start with a B (for black), 2B, and 4B, an HB, which is halfway between hard and soft, and an H (for hard). Clutch pencils have a retractable lead and do not need sharpening. Graphite sticks are chunkier in line and lend themselves to large-scale, bold work.

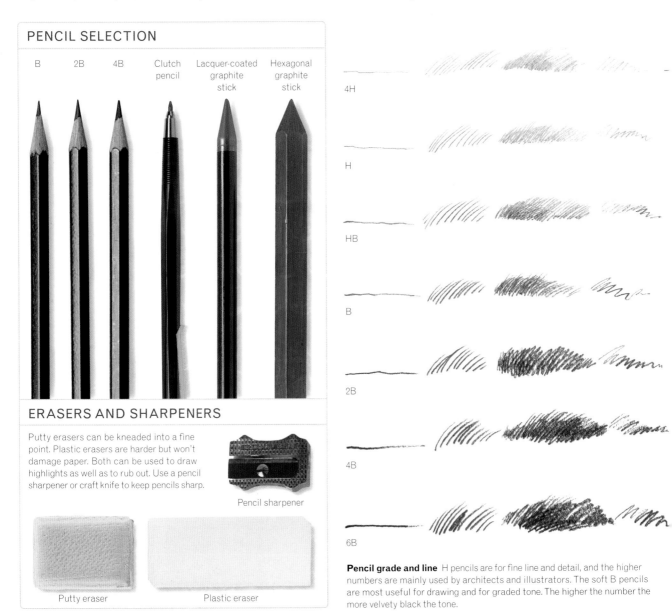

PENCIL SELECTION

B 2B 4B Clutch pencil Lacquer-coated graphite stick Hexagonal graphite stick

ERASERS AND SHARPENERS

Putty erasers can be kneaded into a fine point. Plastic erasers are harder but won't damage paper. Both can be used to draw highlights as well as to rub out. Use a pencil sharpener or craft knife to keep pencils sharp.

Pencil sharpener

Putty eraser

Plastic eraser

4H

H

HB

B

2B

4B

6B

Pencil grade and line H pencils are for fine line and detail, and the higher numbers are mainly used by architects and illustrators. The soft B pencils are most useful for drawing and for graded tone. The higher the number the more velvety black the tone.

COLORED PENCILS

Experiment with a minimum set of 12 or 24 colors to see if you enjoy the medium. A vast range of colors as sets or singles is available to cover all areas of drawing, such as landscapes or portraits. Good-quality brands will not fade. Colored pencils are best for line and you can use one color on top of another in various ways.

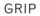

Colored pencil marks Use the pencils to draw outlines, hatch parallel lines, or crisscross them to create shading, make scribbling marks, comb the colors on top of each other, or draw lines close together to create a block of color.

GRIP

When you are drawing, keep your wrist supple and sit up straight rather than hunching over the paper. Experiment with holding your pencil or charcoal in different ways—as if you were about to flick a frisbee, for example, when you are shading. See what happens when you hold your pencil firmly and then more loosely, and make big movements with your whole arm to try to free up your style.

Pencil

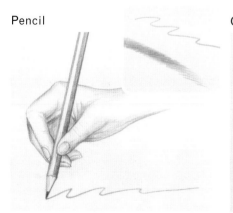

The closer to the point you hold your pencil, the greater your control and scope for detail. Keep your fingers relaxed. If you hold the pencil further up the shaft, your movements will be freer.

Charcoal

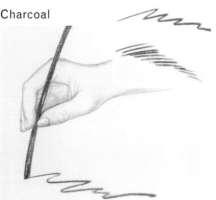

Willow charcoal snaps easily, so hold it gently and press lightly. Break off small pieces and use them on their sides. Compressed charcoal is shorter: cradle it in your palm with relaxed fingers.

Pastel

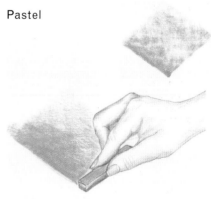

Slide the side of a chalk or oil pastel stick along the surface of the paper to make broad sweeps of color. The harder you press, the denser the pigment. Use the tip of a pastel to draw lines.

Pens, charcoal, and pastels

After some practice with pencils, try using pens, charcoal, or pastels. Pens are excellent for quick sketches or fine detail and, like pencils, are easy to carry around. Charcoal encourages you to draw more loosely and expressively. Pastels are rich in pigment, which gives them strong, vibrant colors. Hard or soft, waxy or fragile, pastels can be bought individually or in sets.

PEN AND INK

Pen and ink is ideal for line work, but you have to look at your subject closely because you cannot erase marks or change your mind. Using pen and ink demands confident line work, whether you are making a rapid sketch or a tonal study. As well as line, try stippling to create tone.

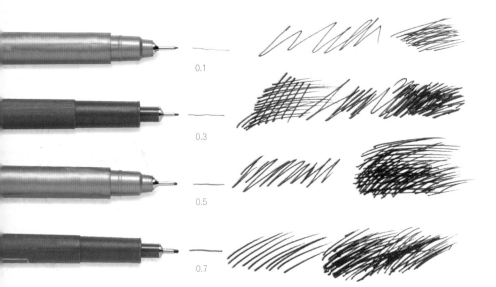

0.1

0.3

0.5

0.7

Technical pens The nibs create lines of uniform width and density. To vary the weight of the line, you need to use different pen sizes—technical pen nibs are measured by width in millimeters.

CONVENIENT PENS

Ballpoint pen

Felt-tip pen

Ballpoint and felt-tip pens are easy to carry around and use. They can produce surprisingly pleasing, spontaneous results, especially for quick, scribbled sketches.

CHARCOAL

Unlike pen, charcoal is easy to rub out and a sweep of an eraser is enough to remove marks. Charcoal responds to pressure and direction, as if it were an extension of your hand, and is superb for loosening tense fingers. Use the tip for lines and the side for sweeps of tone, which you can smudge with a shaper, paper stump (tortillon), cotton ball, eraser, brush, tissue, or your hand.

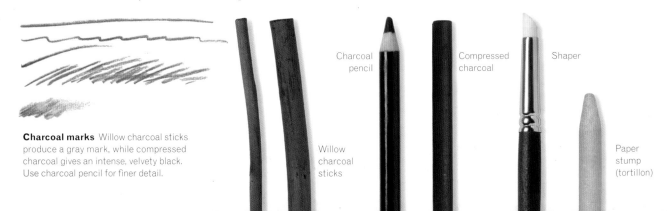

Charcoal marks Willow charcoal sticks produce a gray mark, while compressed charcoal gives an intense, velvety black. Use charcoal pencil for finer detail.

Charcoal pencil

Compressed charcoal

Shaper

Willow charcoal sticks

Paper stump (tortillon)

HARD, SOFT, AND OIL PASTELS

Conté crayons and chalk pastels are made from pigment and gum bound into a paste, hence the name. Chalk pastels are powdery and soft; conté crayons are harder and oilier. Oil pastels are bound with oil and wax, which makes them more buttery in consistency. Like charcoal, chalk pastels need to be sprayed with fixative to stop them from smudging and losing definition.

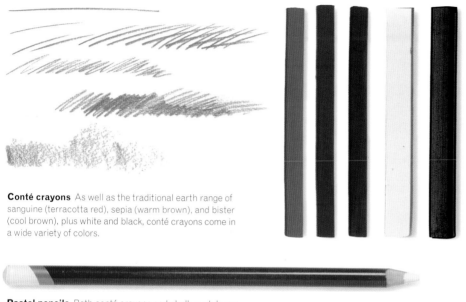

Conté crayons As well as the traditional earth range of sanguine (terracotta red), sepia (warm brown), and bister (cool brown), plus white and black, conté crayons come in a wide variety of colors.

USING FIXATIVE

Fixative is a liquid resin in spray or atomizer form. It glues easily smudged media such as charcoal and pastel to the surface of the paper. Fixative should be applied in a light continuous motion from the top to the bottom of a drawing, which should be held vertically at a distance of about 12 in (30 cm). It is best to use fixative outdoors or at least in a well-ventilated room. Avoid using too much fixative as this will make your drawing look dull. Hairspray can be used as a suitable alternative for fixing your drawings.

Pastel pencils Both conté crayons and chalk pastels are available in pencil form, which crumbles less, for detailed work. Use pencils alongside the sticks.

Chalk pastels All pastels come in full-strength pigments with a range of tints (light tones) and shades (dark tones) for each color. Start with a basic set of 12 or 24 sticks. Chalk pastels are crumbly and respond to light pressure. You can break off pieces and use them on their side to create areas of tone, which can be smudged or blended with your finger or a rag.

Oil pastels The sticks are chunky, so they are best suited to large-scale drawings and for building up rich color, rather than for detailed work. Oil pastels are less crumbly than chalk pastels and rarely need fixing but they get sticky with heat, so cool your hands in cold water if necessary. Because oil pastels are waxy, it is easier to layer colors than to blend them.

Choosing paper

Many sketchbooks contain fine-textured white paper, which is standard for drawing, but you can also buy books with textured paper. Coarse papers are more expensive and range in thickness from charcoal and pastel papers to watercolor surfaces and handmade paper. Mid-toned paper is interesting to work on, as you can use both dark and light media on it. You can also draw on watercolor paper, which is thicker.

TYPES OF PAPER

For most drawings in black and white or conté crayon, standard drawing paper is suitable. It is reasonably smooth and designed to be all-purpose. Ingres paper for charcoal or pastel has a slight tooth (grain). Pastel paper is generally textured so the crumbly pigment has something to cling on to. It is often tinted so that flecks of white paper do not compete with the colors.

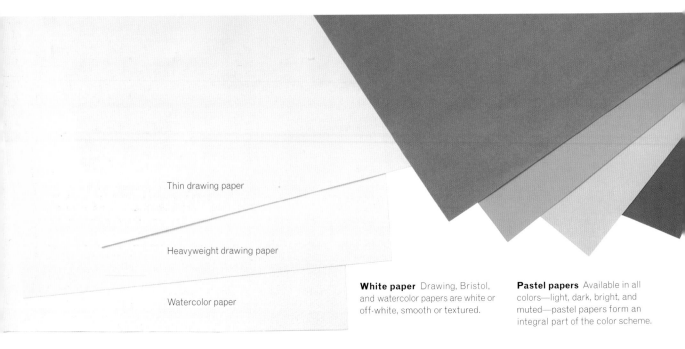

Thin drawing paper

Heavyweight drawing paper

Watercolor paper

White paper Drawing, Bristol, and watercolor papers are white or off-white, smooth or textured.

Pastel papers Available in all colors—light, dark, bright, and muted—pastel papers form an integral part of the color scheme.

PAPER SIZES

Paper is sold internationally in "A" sizes, as shown below, whereas in the US, sizes are given in inches. A4 is the equivalent of 8½ x 11 in, good for sketching while out and about. A3 or A2 are a better size for drawing on. Buying sheets of A1 and cutting them to size is cheaper than buying smaller sheets or sketchpads.

- A1: 23⅜ x 33 in (594 x 840 mm)
- A2: 16½ x 23⅜ in (420 x 594 mm)
- A3: 11 x 17 in (297 x 420 mm)
- A4: 8½ x 11 in (210 x 297 mm)

Sketchbooks
Ringbound sketchbooks are convenient to carry and use on the spot. The cardboard backing gives a firm surface.

SMOOTH OR ROUGH?

The type of paper you use affects the appearance of your drawings. A drawing on smooth paper, which reveals every detail, looks different if it is repeated on textured paper, as the rough surface breaks up the marks you make. In color drawings, you can blend pigments more evenly and delicately on a smooth surface, whereas rough papers create more sparkle and contrast.

SMOOTH PAPER

Charcoal On smooth paper, the lines are soft and the shading smooth. But charcoal really needs some texture to stick to the paper.

Colored pencil Smooth paper shows every detail, such as individual lines of feathering, creating a subtle effect overall.

Pastel It skims over the smooth surface, leaving a light sheen. Like charcoal, it is more suited to rough paper that holds the pigment.

ROUGH PAPER

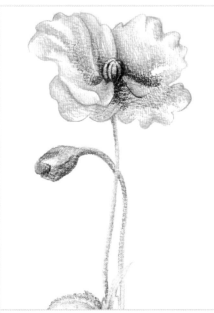

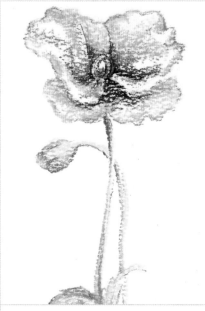

Charcoal Rough paper is better for charcoal, as it adheres to the grain, creating broken lines. This makes a stronger, more dynamic drawing.

Colored pencil The texture breaks up the lines of pencil and layered colors look darker and more intense. Some detail is still apparent.

Pastel The medium looks striking on textured paper. It is good for loose strokes and blocks of color applied with the side of the stick.

Using drawing media

Now is the time to try out different media on a pad of drawing paper. Draw anything that catches your eye, from simple objects at home to details of buildings or landscape. Practice making as many kinds of lines as you can think of: outlines, scribbles, spirals, dots, and dashes. You can use line to create shading, too, using hatching (parallel lines) and crosshatching (series of crisscross lines).

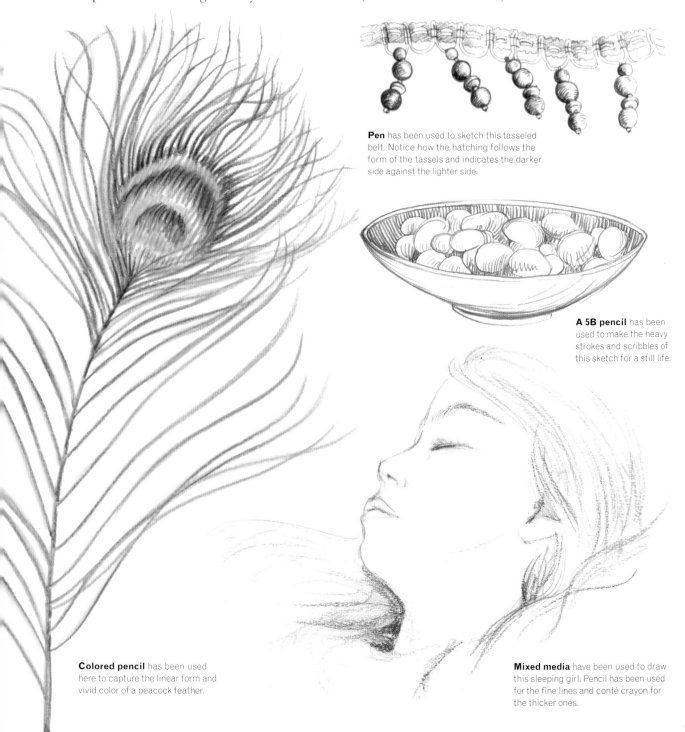

Pen has been used to sketch this tasseled belt. Notice how the hatching follows the form of the tassels and indicates the darker side against the lighter side.

A 5B pencil has been used to make the heavy strokes and scribbles of this sketch for a still life.

Colored pencil has been used here to capture the linear form and vivid color of a peacock feather.

Mixed media have been used to draw this sleeping girl. Pencil has been used for the fine lines and conté crayon for the thicker ones.

COMPARING AND CONTRASTING

Drawing the same object in a variety of media will help you to understand their different qualities, especially when they are all on the same paper. Long, curved strokes shape an object, and hatching or dotting adds volume. The pictures below show how an apple looks when drawn on smooth white drawing paper in black-and-white media and color.

PENCIL

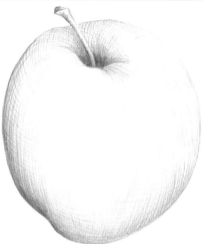

Pencil is finer than charcoal and can be used for delicate silvery hatching and crosshatching that create a mesh of subtly graded tone.

CHARCOAL

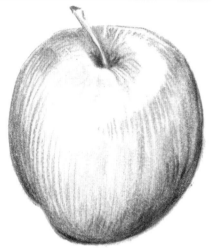

With charcoal, the tonal contrast is greater. Charcoal is better for shading than crosshatching. Thick, soft lines merge around the curving apple.

PEN AND INK

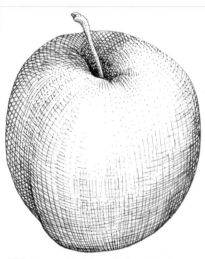

With the even black lines of a fine-nibbed pen, continuous crosshatching builds up density, while dots and dashes speckle the light areas.

CHALK PASTEL

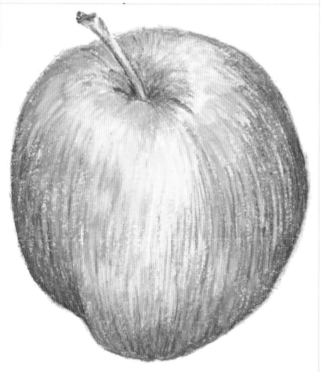

A linear approach is still possible in chalk pastel, here with a limited palette of green, yellow, orange, and red. Rubbing the vertical strokes with an eraser lightens the tone and blends the green areas into the red.

COLORED PENCIL

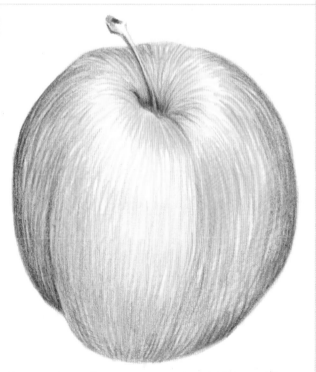

The same colors—yellow, green, orange, and red—laid in lines side by side mix in the viewer's eye and help to shape the apple. Yellow and the bare paper provide the brightest, lightest areas of highlight.

Shape and proportion

To create a realistic drawing, objects need to be a recognizable shape and the right size in relation to each other. You can measure the height and width of one object compared with another quite simply by using a pencil. You can also use the same method to check how far apart objects are. Using a pencil to take measurements, often called sighting, soon becomes second nature when drawing.

TAKING MEASUREMENTS

To check how big things are in relation to other objects, start with a small item, such as the lemon in the drawing below, and use it as the basis for your other measurements. You need to be in the same position for both measuring and drawing, so have your subject matter directly in front of you, so that you do not need to peer over or around your paper to look at it.

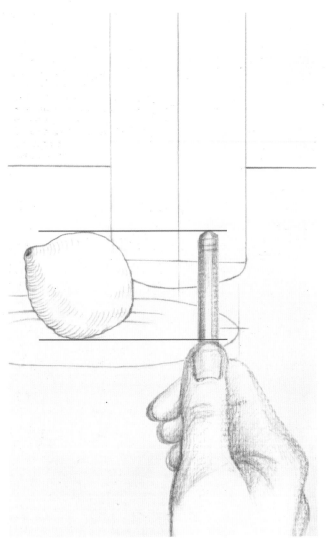

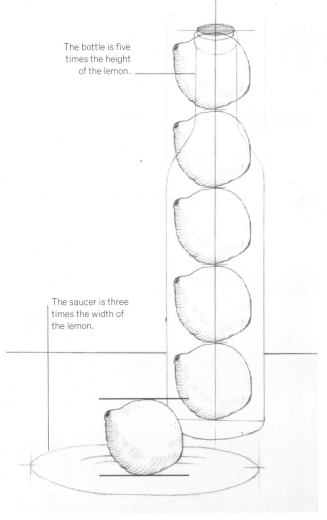

The bottle is five times the height of the lemon.

The saucer is three times the width of the lemon.

To measure an object, such as the lemon in the picture above, hold the pencil upright between your thumb and fingers, at arm's length and keeping your arm straight. Close one eye, then move the pencil until the top of it is level with the top of the lemon. Slide your thumb up the pencil to mark how far down the pencil the bottom of the lemon comes.

Keeping your thumb in the same place, measure how many times the height of the lemon fits into any other object you are drawing, such as the bottle. Measure the width of the lemon in the same way, holding the pencil horizontally, and use this to work out the width of the saucer. You can then map out the objects you are drawing in the correct proportions to each other.

BASIC SHAPES

Once you have worked out the proportions of the objects in a picture, you can rough out the drawing on paper. To make it easier, look at the objects carefully and break them down into basic geometric shapes, such as squares, circles, triangles, rectangles, and ovals.

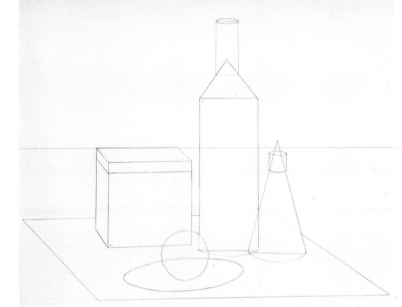

In the preparatory sketch on the right, the bottle has been interpreted as a rectangle with a triangle and tube on top, and the lemon is shown as a circle. If it helps, you can also draw vertical lines through the center of symmetrical objects to help you match one side to the other.

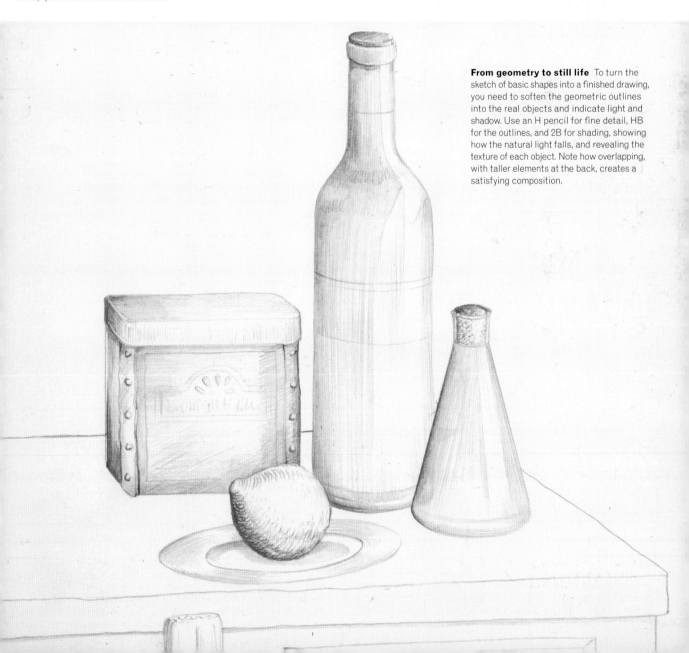

From geometry to still life To turn the sketch of basic shapes into a finished drawing, you need to soften the geometric outlines into the real objects and indicate light and shadow. Use an H pencil for fine detail, HB for the outlines, and 2B for shading, showing how the natural light falls, and revealing the texture of each object. Note how overlapping, with taller elements at the back, creates a satisfying composition.

Shapes and solids

One of the contradictions of drawing is that everything you see is in three dimensions, but your paper is in two. You have to translate the weightiness of objects onto a flat surface. There are rules you can apply to help you do this. The most important rule is to forget what your brain has learned about the external world—minds are adept at overriding visual information with logic. Use your eyes, not your brain.

CONVINCING LINES AND CIRCLES

Drawing straight lines and circles confidently is a matter of practice. Keep the pencil in motion until you have completed the line, as hesitation shows instantly as a kink. When it comes to ellipses—circles flattened in perspective, such as the rim of a cup—the trick is to draw exactly what you see. The shape and slant of an ellipse will vary according to your viewpoint.

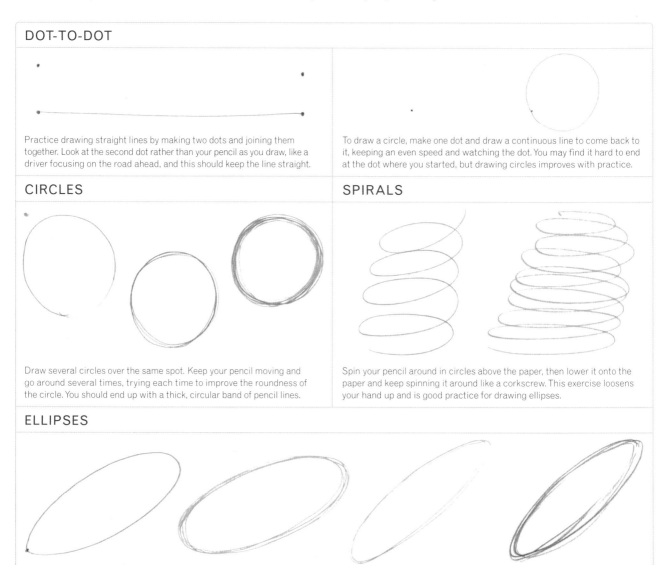

DOT-TO-DOT

Practice drawing straight lines by making two dots and joining them together. Look at the second dot rather than your pencil as you draw, like a driver focusing on the road ahead, and this should keep the line straight.

To draw a circle, make one dot and draw a continuous line to come back to it, keeping an even speed and watching the dot. You may find it hard to end at the dot where you started, but drawing circles improves with practice.

CIRCLES

Draw several circles over the same spot. Keep your pencil moving and go around several times, trying each time to improve the roundness of the circle. You should end up with a thick, circular band of pencil lines.

SPIRALS

Spin your pencil around in circles above the paper, then lower it onto the paper and keep spinning it around like a corkscrew. This exercise loosens your hand up and is good practice for drawing ellipses.

ELLIPSES

A circular shape only appears perfectly round when you look at it head-on or from directly overhead. Otherwise it looks like an ellipse. Practice drawing ellipses in the same way you practice making circles, so that you avoid the common mistake of making the ends pointed. The different directions of tilt depend on the angle from which you are looking at the shape. The more it is turned away from you, the narrower the ellipse seems.

DRAWING GEOMETRIC SHAPES

If you look at a cube head-on, or from directly above, it appears flat. But as soon as you can see more than one side, horizontal lines appear to slant. The way to make a cube look like a cube and not a square is to faithfully copy the angle of the slant as you see it. Use your pencil to take measurements. The only lines that stay horizontal are the ones on your eye level.

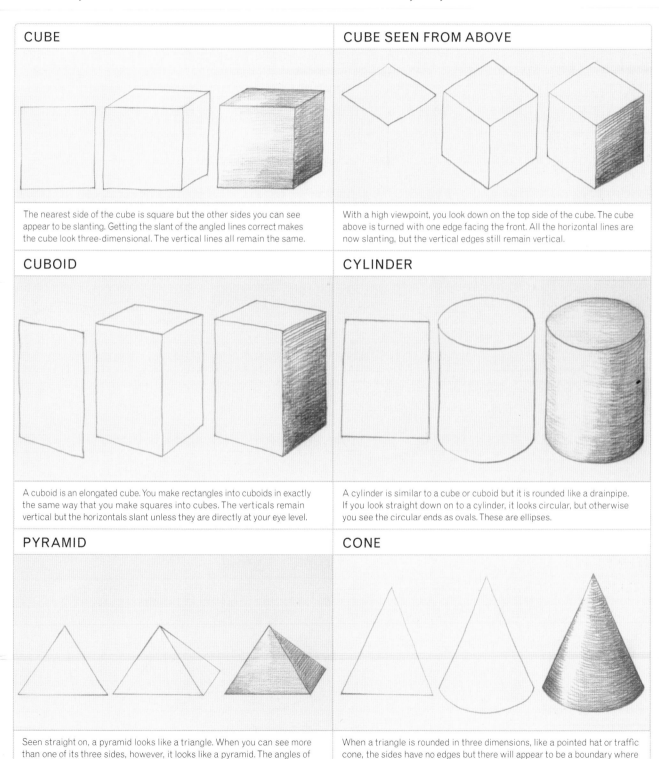

CUBE

The nearest side of the cube is square but the other sides you can see appear to be slanting. Getting the slant of the angled lines correct makes the cube look three-dimensional. The vertical lines all remain the same.

CUBE SEEN FROM ABOVE

With a high viewpoint, you look down on the top side of the cube. The cube above is turned with one edge facing the front. All the horizontal lines are now slanting, but the vertical edges still remain vertical.

CUBOID

A cuboid is an elongated cube. You make rectangles into cuboids in exactly the same way that you make squares into cubes. The verticals remain vertical but the horizontals slant unless they are directly at your eye level.

CYLINDER

A cylinder is similar to a cube or cuboid but it is rounded like a drainpipe. If you look straight down on to a cylinder, it looks circular, but otherwise you see the circular ends as ovals. These are ellipses.

PYRAMID

Seen straight on, a pyramid looks like a triangle. When you can see more than one of its three sides, however, it looks like a pyramid. The angles of the triangles depend on your viewpoint and how many edges you can see.

CONE

When a triangle is rounded in three dimensions, like a pointed hat or traffic cone, the sides have no edges but there will appear to be a boundary where your sight of it ends. The base becomes a half-ellipse, or a semicircle.

Building a drawing

Many objects, both natural and man-made, are geometric in basic shape. Visually breaking down what you see into squares, circles, and other familiar shapes can help you to observe things more accurately, relate one part to another, and draw what you see. Start by drawing the overall shapes, then break the object down into smaller shapes before adding shading and detail.

OBJECTS AROUND THE HOME

Start with inanimate objects, which you can place where you want. Sit right in front of your subject, resting your drawing board on the back of a chair, so that you can look up at what you are drawing and then back at your paper without changing eye level. Use an HB pencil on drawing paper. Don't worry about drawing the background: just concentrate on the subject.

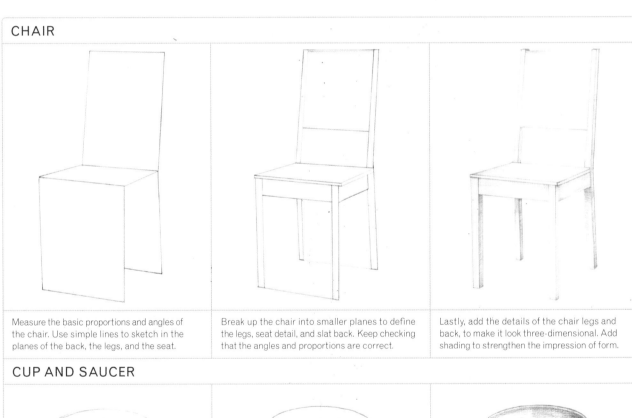

CHAIR

Measure the basic proportions and angles of the chair. Use simple lines to sketch in the planes of the back, the legs, and the seat.

Break up the chair into smaller planes to define the legs, seat detail, and slat back. Keep checking that the angles and proportions are correct.

Lastly, add the details of the chair legs and back, to make it look three-dimensional. Add shading to strengthen the impression of form.

CUP AND SAUCER

Draw an axis for the center of the cup rim and the saucer. Measure the height and depth of them, then draw the two matching ellipses.

Draw the two ellipses on the saucer where the cup rests. Look closely at the cup, then sketch its sloping sides and the curve of the base.

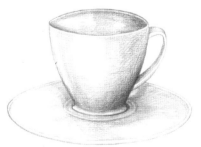

Draw the rim of the saucer and the handle of the cup, then any other small details. Add shading last of all, to create a sense of form.

PEOPLE

You can simplify the human form in just the same way as objects. Measure the proportions of the figure and seat with a pencil and work out the scale on a rough sketch first, so that you can fit the whole figure onto your piece of paper without cropping off its head or feet or leaving it floating in space. Your first outlines will look like a stick figure, but all the proportions will be correct.

FIGURE

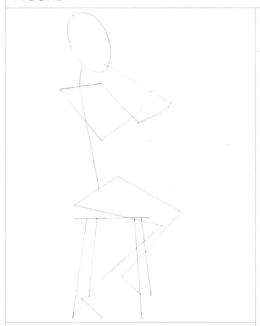

Plot how the basic shapes and lines relate to each other: the oval for the head and the angles of the arms and legs, and position the body so that it is centered over the stool.

Draw a cone for the neck, a triangle for the shoulders, a rectangular torso, and long, tapering rectangles that are joined at right angles for the arms and legs.

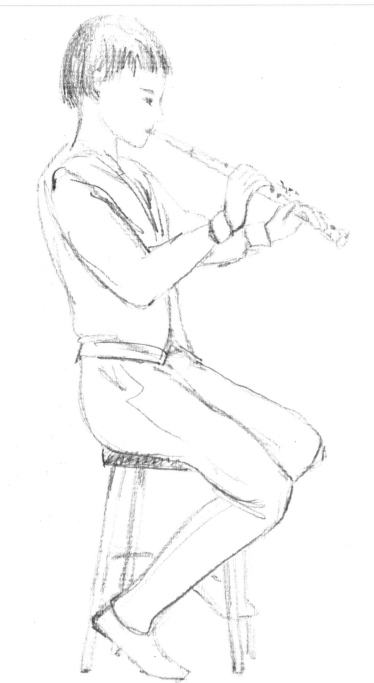

Using the geometric shapes as positional guides, start drawing the figure properly, modifying the shapes according to what you see. Keep checking back to your model as you work, and use an eraser to rub out the original sketch marks once you have corrected them.

Adding tone

Tone is how pale or dark something is. The play of light and shade is what gives objects form and weight, so adding tone makes a picture look three-dimensional. When it comes to drawing, light, shade, and your subject matter are all equally important. How you apply tonal shading depends on the medium that you are using as well as the texture and color of the paper that you are drawing on.

DRAWING A SPHERE

Some objects, such as cubes, can appear three-dimensional because of linear perspective. With a circle, however, the only way to give it volume and turn it into a sphere is to add shading.

All the spheres below were drawn on the same rough off-white watercolor paper. The method of shading, however, varied according to the medium used.

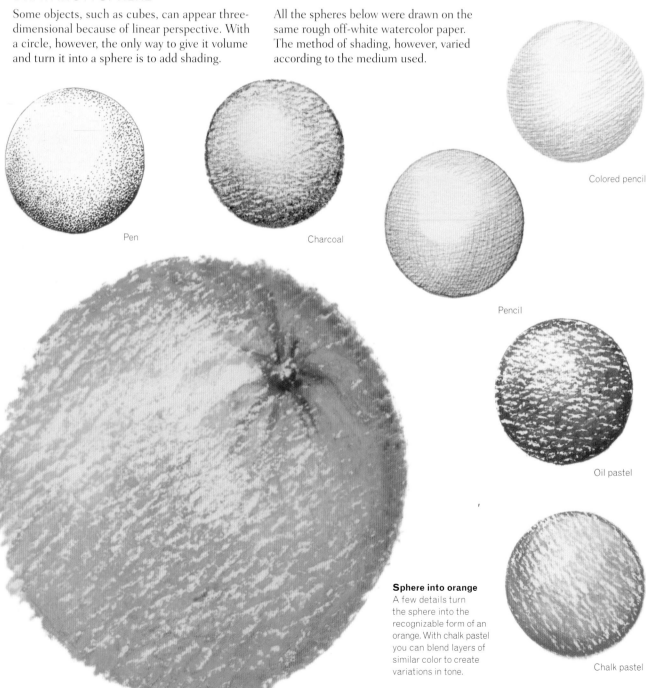

Pen

Charcoal

Colored pencil

Pencil

Oil pastel

Sphere into orange
A few details turn the sphere into the recognizable form of an orange. With chalk pastel you can blend layers of similar color to create variations in tone.

Chalk pastel

TEXTURE

Showing texture is like drawing tone in more detail: it involves capturing the play of light and shadow on every speck of the object's surface, rather than just on the overall shape. To convey texture, imagine handling the surface of the object and draw the sensation that touching the object evokes. Below are different treatments in different media of the same subject matter.

PENCIL

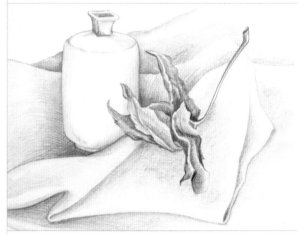

H and 2H pencils were used on smooth white drawing paper to draw the fine outline and hatching on the jar. These hard pencils create a faint but sharp line.

For the denser texture of the leaf, a B pencil was used with varying pressure to alter the weight of the line. A 3B pencil was used to create the soft tones of the fabric behind.

PEN

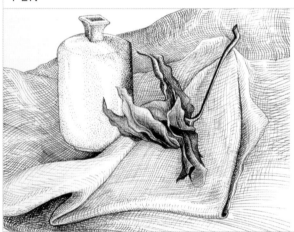

Here, on the same smooth paper, stippling marks were made with a pen. The close dots produced the bottle's shadow and areas of paper were left bare for the highlights.

The texture of the cloth was brought out by crosshatching. Total black coverage in the shadows and looser coverage in the areas of light created the curves of the leaves.

CHALK PASTEL

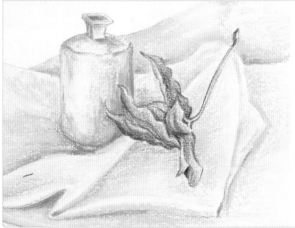

In this version, pastel paper and a looser style were used with the powdery medium of pastel. Gray pastel was blended with a finger for the smooth surface of the bottle.

Different tones of brown were used to reveal the form of the leaves. Their clear outline suggests their crisp, papery texture against the soft folds of the fabric.

Using perspective

The way to create an illusion of three dimensions on a flat sheet of paper is to use perspective. Objects in the distance may not really be smaller than they would be in the foreground, but they look as if they are. Perspective makes parallel lines going into the picture space appear to converge. The spot where they meet is called a vanishing point, and you can use it to calculate the angles of other lines in the drawing. The only lines that do not join the vanishing point are horizontals at your eye level and verticals.

ONE-POINT PERSPECTIVE

A classic example of linear perspective is a road or railroad in the center of a picture converging to a point in the background. Indoors, you can see linear perspective by looking down a hallway. Walls appear to converge, the floor seems to rise, and the ceiling to lower, all to a single point. This one-point perspective only works when the subject is head on: if you imagine the sheet of paper as a pane of glass, the road or railroad has to pierce it at right angles.

The width of the road seems to narrow as it recedes. Eventually the two edges meet.

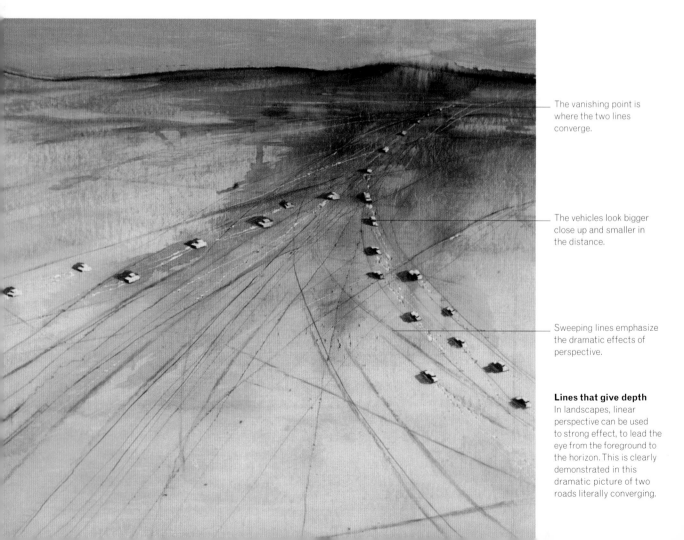

The vanishing point is where the two lines converge.

The vehicles look bigger close up and smaller in the distance.

Sweeping lines emphasize the dramatic effects of perspective.

Lines that give depth
In landscapes, linear perspective can be used to strong effect, to lead the eye from the foreground to the horizon. This is clearly demonstrated in this dramatic picture of two roads literally converging.

TWO-POINT PERSPECTIVE

One-point perspective applies when parallel lines go straight into the picture, but often a subject is viewed at an angle. In this case, horizontal lines converge at two vanishing points, one on each side of the drawing. Two-point perspective often comes into play with buildings and other objects with straight sides. Use it as a guiding principle for realistic drawing.

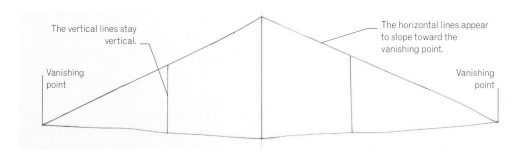

The vertical lines stay vertical.

The horizontal lines appear to slope toward the vanishing point.

Vanishing point

Vanishing point

House in perspective
Two sides of the house are visible. The principal lines of the building converge at vanishing points on the horizon line either side of the drawing (beyond the edge of the paper). Starting with a simple perspective diagram helps to plot the structure of the house.

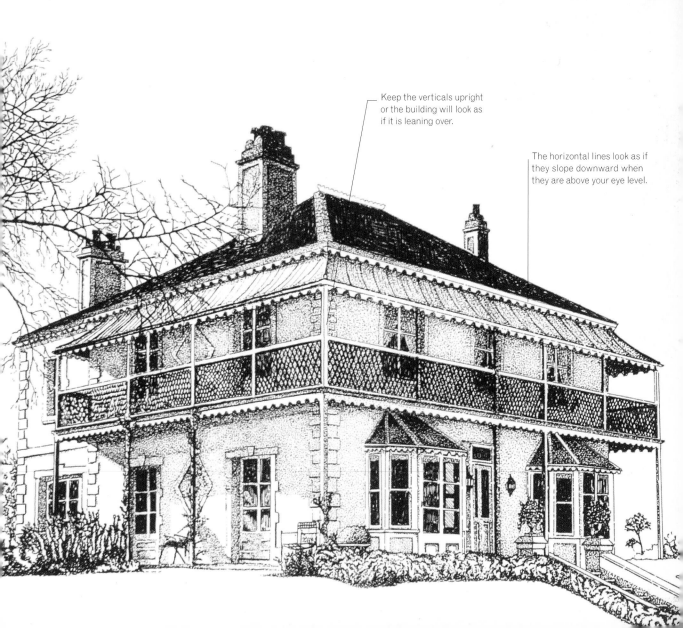

Keep the verticals upright or the building will look as if it is leaning over.

The horizontal lines look as if they slope downward when they are above your eye level.

Composition

As the artist, you have to decide what to include in your picture and what to leave out, where to position each element, and how the different parts interact to form a whole. You want a viewer to look at the entire picture, but the eye cannot take in everything at once. The key to good composition is to give the viewer visual stepping stones around the picture, and to include a center of interest for the eye to focus on.

USING A VIEWFINDER

To help work out the best viewpoint on a scene, use a viewfinder. Cut out two L-shaped pieces of cardboard and paint them black, the least distracting color. Hold them up against the given scene—whether it is a landscape, a still life, or a figure study—and you have an automatic picture frame. The viewfinder makes it much easier to visualize what a composition will look like on paper.

Change the size and shape of the composition by moving the frames closer together or further apart.

CHOOSING A FORMAT

Before you firm up the composition, you need to decide what size you are working at and what shape (format) the paper is. If it is rectangular, you can have the short sides top and bottom (portrait format) or sideways (landscape format), or alternatively you can work to a square.

Portrait

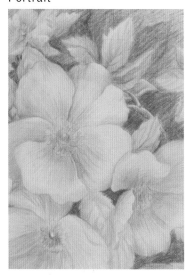

Landscape

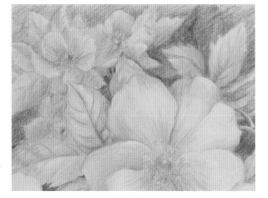

Often used for landscapes, a wide shape can give a satisfying ratio of sky to land. It is a good choice for many compositions.

The tall format is called portrait as it is a convenient shape for head and shoulders or a figure. It suits other tall shapes, too.

Square

Although a square format encourages a well-balanced composition, it can make your drawing look static and lifeless. Use with caution.

APPLYING THE RULE OF THIRDS

The center of interest in a picture is called a focal point because it immediately attracts the eye. Where you put the focal point is crucial and there is an easy way to give it maximum effect. Divide the paper into thirds and place the focal point on any of the intersections. Based on mathematical proportions, the rule of thirds can give a picture harmony and visual impact.

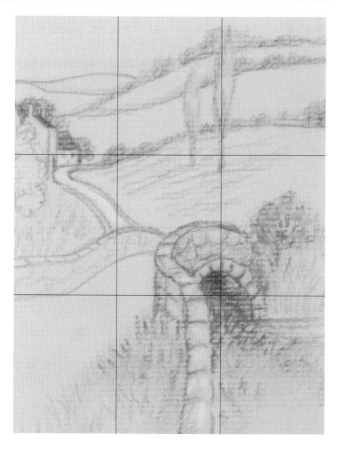

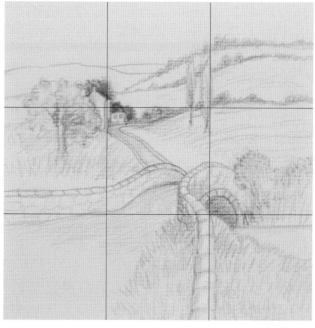

In a square format you can apply the rule of thirds just as for a rectangular composition. The curve and masonry of the bridge fall on one intersection and a secondary focal point, the house, on its diagonal opposite.

In a portrait format the bridge dominates on the lower right intersection. Notice how the road leads the eye from the bridge to the house, which is now less important, but provides middle-ground interest and a visual break.

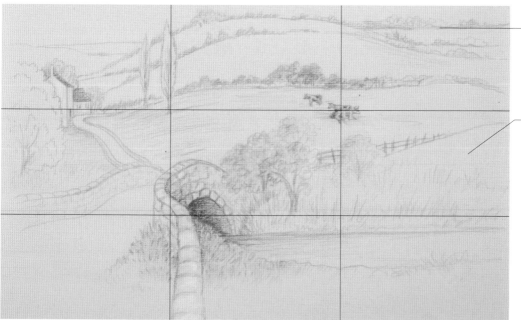

The horizon line is high, with just enough sky to put the picture in context.

The river and open field suggest more landscape beyond the picture frame.

In a landscape format the bridge falls on the front left intersection, directly in line with the upright tree behind. The cows form a secondary focal point diagonally opposite. The relative sizes —large bridge, small cows and house—emphasize the impression of depth.

Seizing the moment

The best way to improve your drawing is to practice. Try to do five to ten minutes sketching every day rather than, or as well as, a longer session once a week. Whatever you draw will improve your powers of observation, so choose what interests you. Leave out or simplify any elements that cause your attention to wander. Avoid talking while you draw, as it will distract you, and immerse yourself in the moment.

KEEPING A SKETCHBOOK

Carry a sketchbook and a pencil or pen around with you everywhere so you can sketch at any opportunity. Regard your sketchbook as a visual diary: don't show it to anyone and use it to make a quick record of anything that interests you. If you are drawing people in public, it is better to remain unobserved, to stop them from peering over your shoulder and adding their comments.

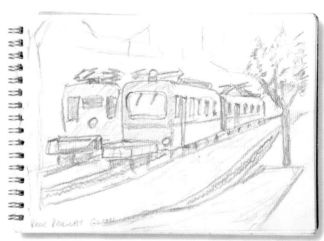

Trains give you plenty of practice drawing objects based on geometric shapes. If you wait at a station, you can sketch passengers as well as the trains themselves, which are easier to draw when stationary at the platform.

Portable sketchbooks need to be small. A letter-sized, 8.5 x 11 sketchbook is a perfect size to use. The hard back means you don't need a drawing board, and you can use a clip to hold the page in place.

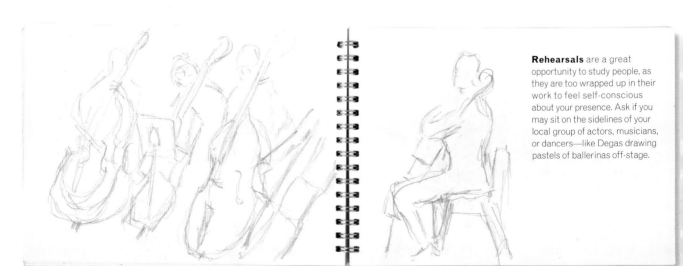

Rehearsals are a great opportunity to study people, as they are too wrapped up in their work to feel self-conscious about your presence. Ask if you may sit on the sidelines of your local group of actors, musicians, or dancers—like Degas drawing pastels of ballerinas off-stage.

FINDING SUBJECTS

Whether indoors or outdoors, you don't need to travel far to find inspiration. Make still lifes at home from kitchen utensils—a table set for a meal helps you get to grips with the ellipses of plates and glasses. All types of furniture are a lesson in linear perspective. Persevere, and taking measurements will become second nature. Start with shapes and shadows before adding detail.

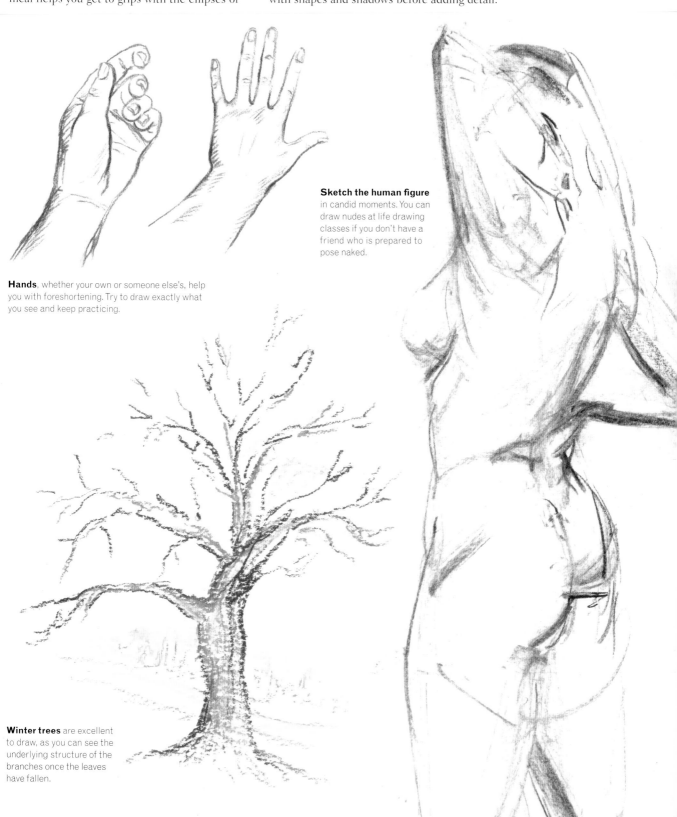

Sketch the human figure in candid moments. You can draw nudes at life drawing classes if you don't have a friend who is prepared to pose naked.

Hands, whether your own or someone else's, help you with foreshortening. Try to draw exactly what you see and keep practicing.

Winter trees are excellent to draw, as you can see the underlying structure of the branches once the leaves have fallen.

Capturing movement

When you are drawing something that is moving, you have to work fast. Forget about details and jot down the essentials. You will develop your own style of drawing shorthand, as individual as your handwriting.

Set yourself a time limit, and try to distil the energy of your subject. You can also train your memory by concentrating on looking more than on drawing. You can then try to recreate the image on paper later on.

QUICK SKETCHES

The easiest actions to pin down on paper are the repetitive ones. Someone swimming, a child on a trampoline, people rowing down a river, a tractor harvesting in a field, airplanes taking off, or pouring rain, all of these things make rhythmic movements that you can study. Multiple or sudden actions, such as children at play or a bird taking off, are more challenging to draw.

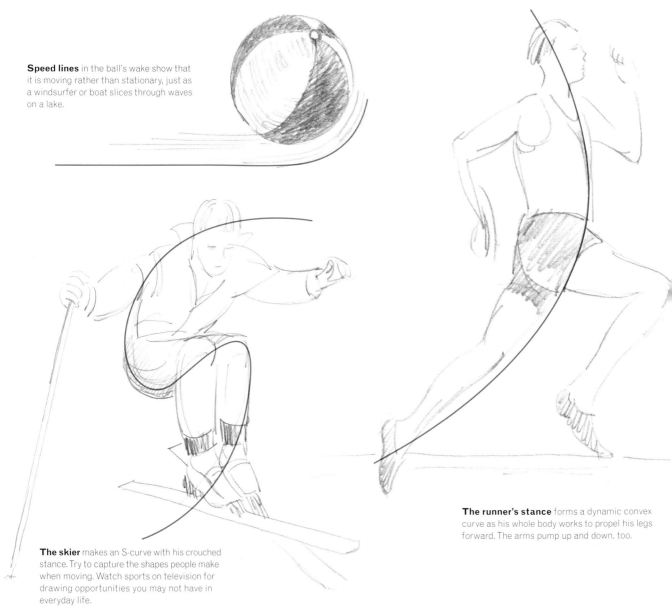

Speed lines in the ball's wake show that it is moving rather than stationary, just as a windsurfer or boat slices through waves on a lake.

The skier makes an S-curve with his crouched stance. Try to capture the shapes people make when moving. Watch sports on television for drawing opportunities you may not have in everyday life.

The runner's stance forms a dynamic convex curve as his whole body works to propel his legs forward. The arms pump up and down, too.

A scuttling crab moves its legs in arcs. Drawing in the key lines of direction helps to get the overall thrust of the movement right.

Pelting rain bouncing off the pavement can be recreated with short stabbing pastel strokes pinging off at right angles. Drawing directional streaks with an eraser helps to convey the watery blur of a sudden downpour.

Dogs, whether panting, chasing, barking, or eating, are rarely still except when asleep. Sketch them in the many poses that sum up what it is to be a dog and not, say, a cat.

Understanding color

Colors can make you feel happy or sad, they can stimulate or soothe, attract or repel. They influence one another and people looking at your pictures. The more you know about how colors react when placed side by side, the better you can use them. The easiest way to understand how colors are related to each other is to look at a color wheel, which is like a cross-section of a rainbow made into a circle.

PRIMARY AND SECONDARY COLORS

Red, yellow, and blue are known as primary colors because they cannot be mixed from any other colors. If you mix two primary colors together, you make so-called secondary colors: red and yellow make orange; yellow and blue make green; and blue and red make purple. With pastels and colored pencils, you can only mix colors together directly on your paper.

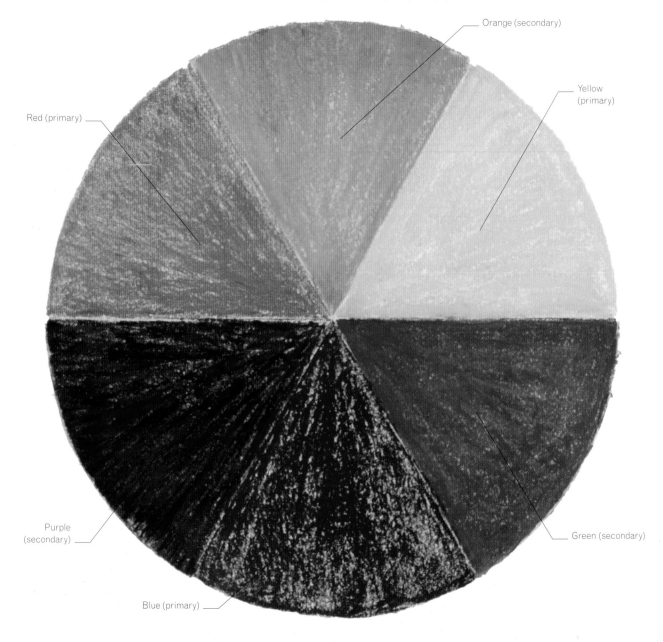

Red (primary)

Orange (secondary)

Yellow (primary)

Green (secondary)

Purple (secondary)

Blue (primary)

HARMONY AND CONTRAST

Colors that are near each other on the color wheel are similar and harmonize when used together. Colors that are far apart contrast with each other and look vibrant when used together. You can use similar amounts of each color or let one predominate, and just use accents of another. Color and composition are closely linked, with one reinforcing the other.

Yellow, orange, and red look dazzling set against blue.

The dark stem and stippled center contrast strikingly with the red petals.

Basket of flowers A riot of color has been created with oil pastels in a limited range of colors. The leaves strike a calmer note and the blue background acts as a foil for the bright flowers.

Dabs and streaks of blue throw the red into relief.

The yellow harmonizes with the red to create an overall fiery glow.

Fireworks display Red dominates this drawing. The yellow highlights give an eerie sense of unnatural light, and silhouette the standing figures against the exploding fireworks.

Applying color

A pure red contains just its own color and nothing else. You can add white or black to make it paler or darker. You cannot make a color brighter than it already is, but you can make it duller by adding another color.

Dull in this sense does not mean dreary; it is just the opposite of bright. In drawing media, paler and darker tones, or brighter and duller versions, tend to come in separate sticks or pencils.

MIXING COLOR ON PAPER

As well as buying different tones and brightnesses —for instance, reds from crimson to pink, blues from midnight navy to turquoise to baby powder blue—you can mix colors on the paper.

Layering involves applying one color over another so that the bottom one affects the top color. Alternatively, you can create an optical mix by using colors close together.

SCUMBLING

Blue over pink

Pink over blue

Blue over yellow

Yellow over blue

The technique of scumbling is a way of building up pastel in layers. Lightly draw the side or blunted tip of a soft pastel across the paper to create the first layer of color. Do the same with a second color to veil but not obscure or lift the previous layer. The broken color sparkles, and the randomness of the marks adds textural interest. The order in which you apply the colors greatly affects the final appearance.

LAYERING COLOR

Conté crayons and all types of pastel stick can be used on their side in broad strokes to create flat areas of single or layered color, in this case blue over yellow and blue over orange. Where the pastels overlap, they mix optically to create a third green or brown color.

CROSSHATCHING

With colored pencils, pastel pencils, and the tips of pastel sticks, you can use linear techniques. Make parallel lines with one color (hatching), then add another set of lines across them at a different angle (crosshatching).

FEATHERING

Interlock fine lines so that the two colors shimmer and you can still see the individual marks. Feathering is another linear technique, useful for pencils, in which the colors blend visually rather than on paper.

COLORED PENCIL DRAWINGS

Once you have experimented with the range of linear marks you can make with colored pencil, try using them in a finished drawing. Different techniques work in different places. In the drawing below, a full range of colored pencil techniques is used. The brightest colors are in the foreground, with more muted application toward the background.

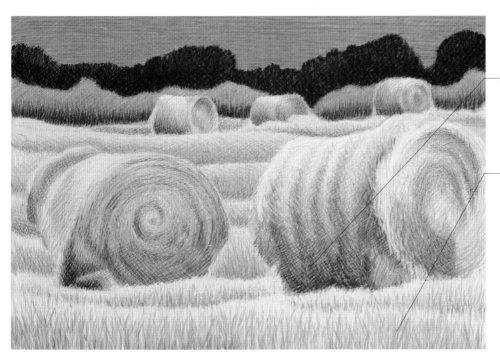

Crosshatching captures the close texture of the bales of hay.

Feathering makes the stalks glimmer and gleam.

Hay bales
The same color scheme is used throughout, which unifies the drawing. Red predominates and advances in the foreground, with touches of green. In the background, the color balance shifts to mainly green with an underlayer of red.

PASTEL ON DIFFERENT COLORED PAPERS

All pastel papers come in a range of tints and mid-tones, and strong bright or dark colors. The color of the paper has a marked effect on the drawing, as seen below. You can also use pastel on watercolor paper, which is thicker. The more texture the paper has, the more pastel it will hold, so you can layer colors and completely cover the underlying surface if you wish.

Watercolor paper

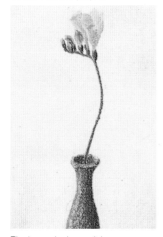

The image looks weak because the white of the paper deadens the colors of the flower and vase. This is why it is preferable to use tinted or colored rather than white paper.

Purple paper

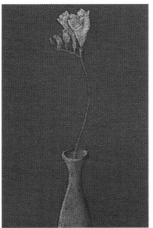

The flower and stem look luminous against the contrasting background. As blue and purple are next to each other on the color wheel, the vase and the paper harmonize.

Red paper

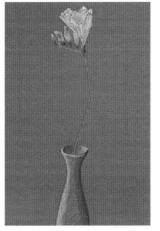

The red and green contrast and vibrate so that the image looks extremely bright. The paper is such a strong color that the background insists on attention.

Peach paper

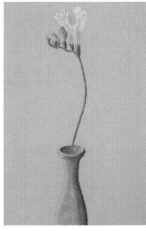

The image is subtle but effective. The paper color mellows the blue of the vase but it is dark enough to highlight the flower, which would be lost on white paper.

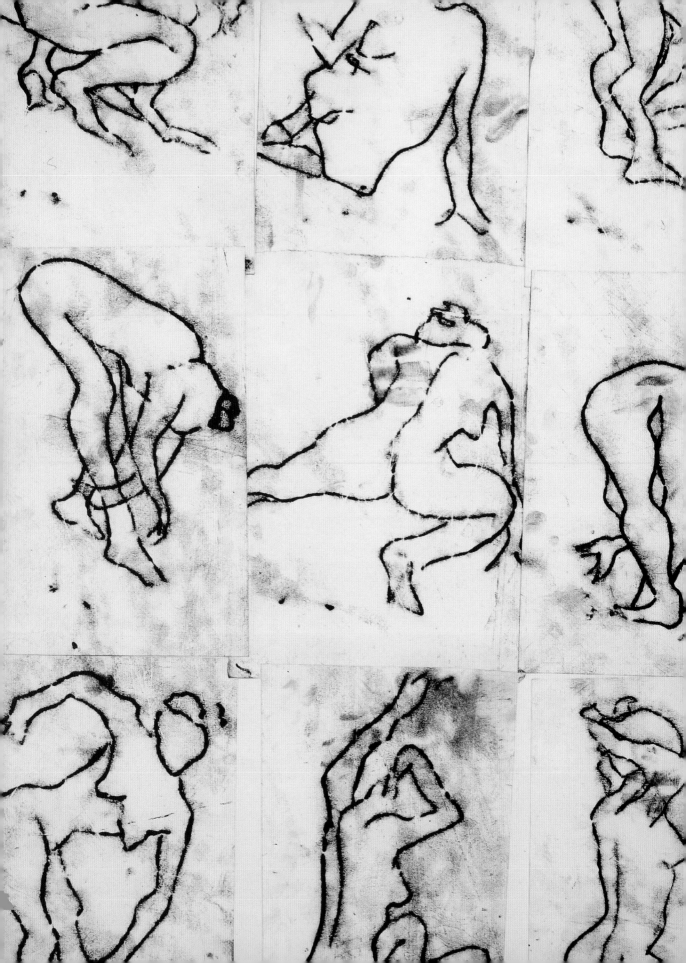

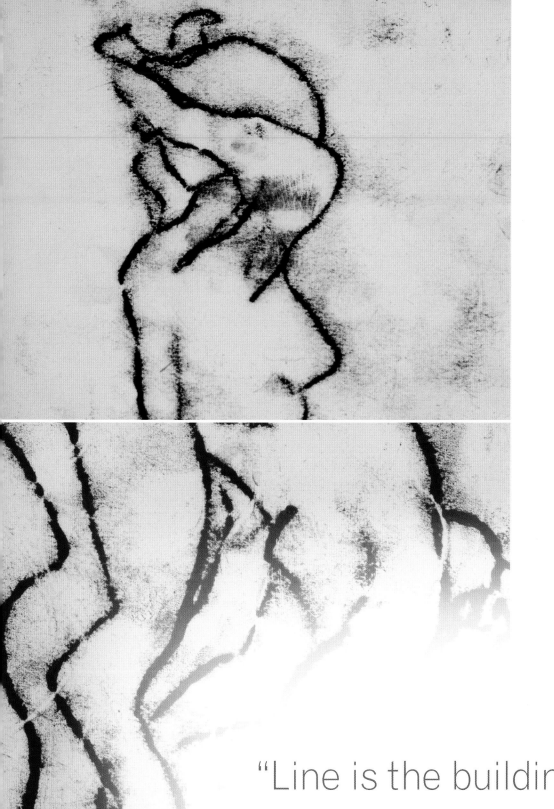

"Line is the building
block of drawing."

The power of line

The Swiss-born artist Paul Klee described drawing as "taking a line for a walk." Line is the fundamental drawing technique and you can use it to produce pictures of the utmost sophistication or simplicity. Pencils, pens, and colored pencils are all ideal for line work. You can work in outline alone, called contour drawing, in which case you concentrate on shape. You can combine outline with hatching to create a tonal drawing or you can simply vary the weight of line to indicate volume and substance.

DIFFERENT TYPES OF LINE

With pencil or charcoal you can explore the full expression of line—thin, thick, bold, delicate, broken, continuous, dark, light. With a technical pen you have a consistent line. No one type of line is better than another: each has its place. Try sketching with different kinds of lines, adapting the treatment to the subject matter, and see how it improves the character of the drawing.

Pen outline

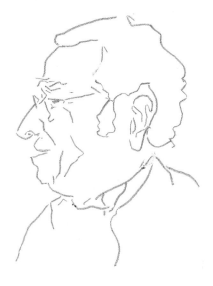

A fine-point pen creates regular lines that are ideal for a rapid sketch. This distinctive profile has been captured in just a few seconds, using very few lines.

Pencil for shading

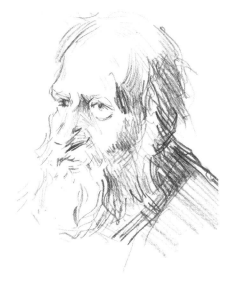

Here, soft pencil has been used for dense, crayonlike lines and a harder pencil for crisp lines. The lines follow the contours of the old man's features and beard. Several sketch lines have been added alongside hatching for a mid-tone and crosshatching for a dark tone.

Pencil outline

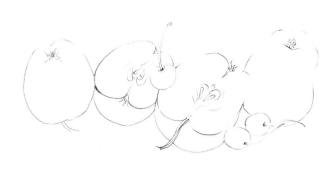

Gentle, fluid lines emphasize the curves of the fruit, their stems, and cores. A sense of form has been created by pressing harder where the two apples on the left meet, while in other places the line has been broken for a delicate touch.

Light and dark pencil lines

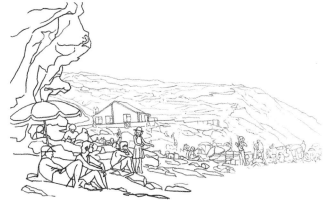

The lighter weight of line in the distance implies receding space. The detail also fades—the people along the beach are mere squiggles. This rule of dark, crisp foreground and pale, hazy background lines is called aerial perspective.

USING NEGATIVE SPACE

Every line that you draw creates two edges. The edges may be a boundary between one object and another or they may show the object and a gap. The gaps between positive forms are called negative space and, despite the dismissive name, are highly important for a good composition. Drawing negative space rather than the subject can free you up and strengthen the drawing.

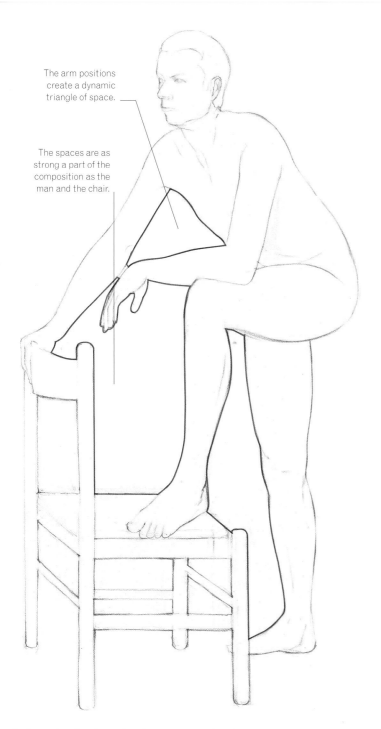

The arm positions create a dynamic triangle of space.

The spaces are as strong a part of the composition as the man and the chair.

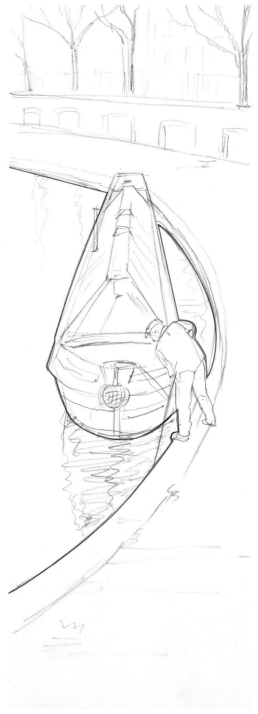

In figure drawing the angles of arms and legs often form strong negative spaces. Linear objects based on geometric shapes, such as chairs, are also a gift in terms of negative spaces. Here, the combination of a figure and a chair sets up a series of intriguing spaces.

The arc of the canal creates interesting negative space around the boat, setting curves against straight lines. The arches between the trees in the background and the holes pierced into the wall make patterns of negative space.

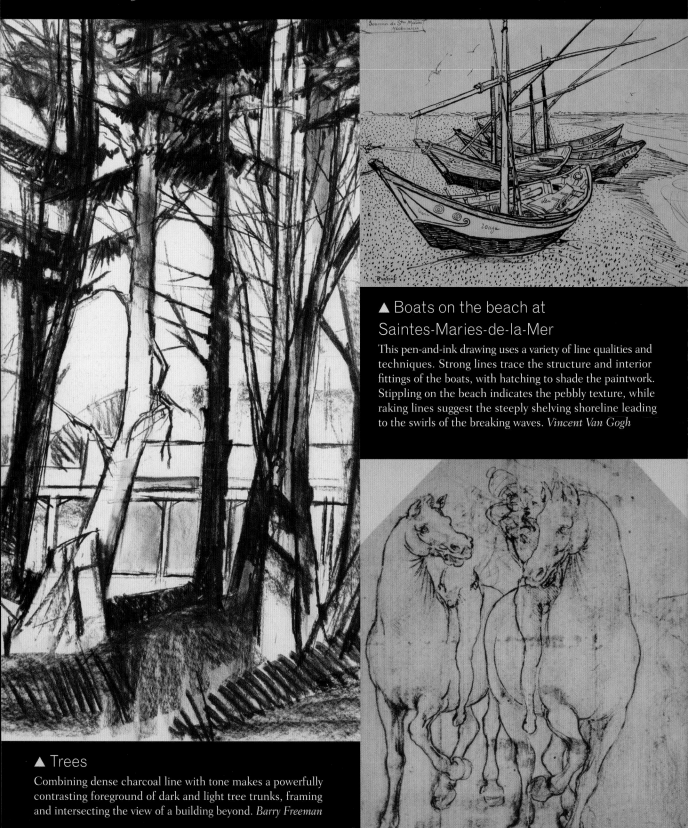

Gallery

Forceful or delicate, line is the key to drawing and the technique that most artists use when learning to interpret what they see on paper.

▲ Boats on the beach at Saintes-Maries-de-la-Mer

This pen-and-ink drawing uses a variety of line qualities and techniques. Strong lines trace the structure and interior fittings of the boats, with hatching to shade the paintwork. Stippling on the beach indicates the pebbly texture, while raking lines suggest the steeply shelving shoreline leading to the swirls of the breaking waves. *Vincent Van Gogh*

▲ Trees

Combining dense charcoal line with tone makes a powerfully contrasting foreground of dark and light tree trunks, framing and intersecting the view of a building beyond. *Barry Freeman*

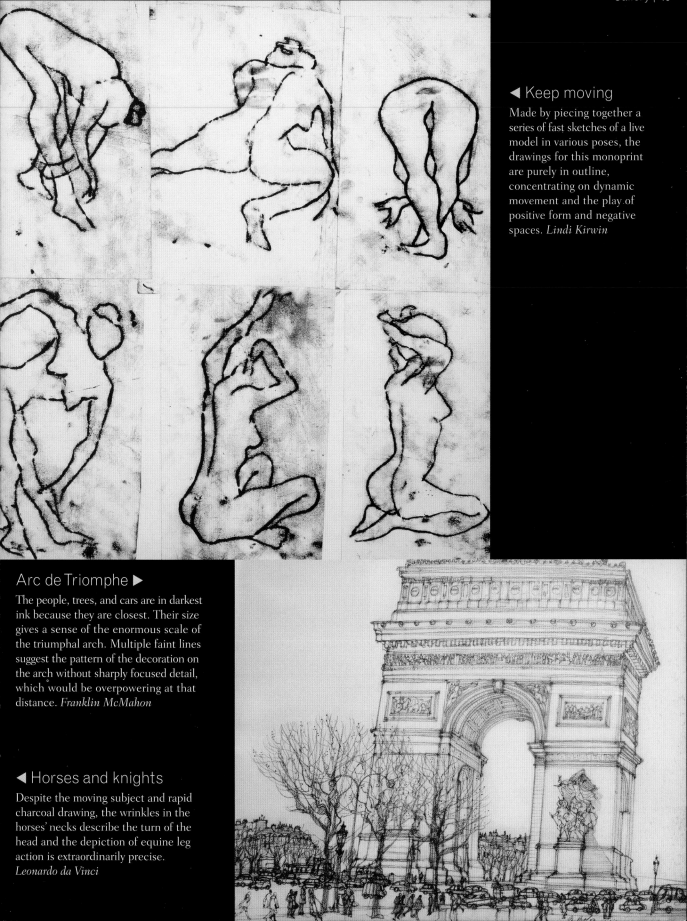

◀ **Keep moving**

Made by piecing together a series of fast sketches of a live model in various poses, the drawings for this monoprint are purely in outline, concentrating on dynamic movement and the play of positive form and negative spaces. *Lindi Kirwin*

Arc de Triomphe ▶

The people, trees, and cars are in darkest ink because they are closest. Their size gives a sense of the enormous scale of the triumphal arch. Multiple faint lines suggest the pattern of the decoration on the arch without sharply focused detail, which would be overpowering at that distance. *Franklin McMahon*

◀ **Horses and knights**

Despite the moving subject and rapid charcoal drawing, the wrinkles in the horses' necks describe the turn of the head and the depiction of equine leg action is extraordinarily precise. *Leonardo da Vinci*

1 Overlapping leaves

This project will help you to focus attention not just on the lines of the subject you are drawing, in this case some sycamore leaves, but also on the shapes that are created in the gaps between and around them—the negative spaces. The relationship between form and space is important when planning a composition, as all the lines and shapes have to relate to the whole. Negative space also helps you position the individual elements of the subject in correct relationships to one another when working on the initial outline of the drawing.

EQUIPMENT
• 8½ x 11 in drawing paper
• HB pencil

TECHNIQUES
• Using negative space
• Drawing outlines

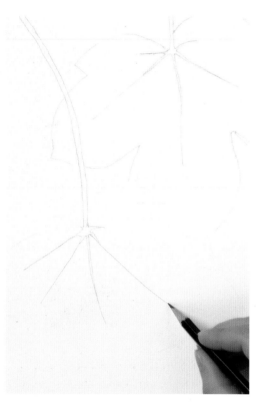

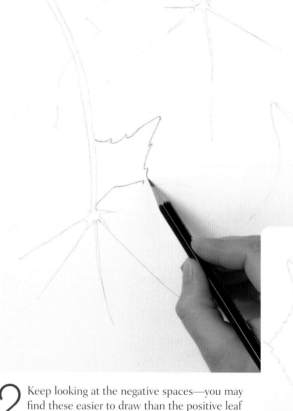

1 Carefully map the position of the sycamore leaves with a faint outline, using the negative spaces to help with accuracy. Lightly sketch in the stems and the leaf veins.

2 Keep looking at the negative spaces—you may find these easier to draw than the positive leaf shapes. Once you are happy with the outlines, darken them by pressing harder with the pencil.

BUILDING THE IMAGE

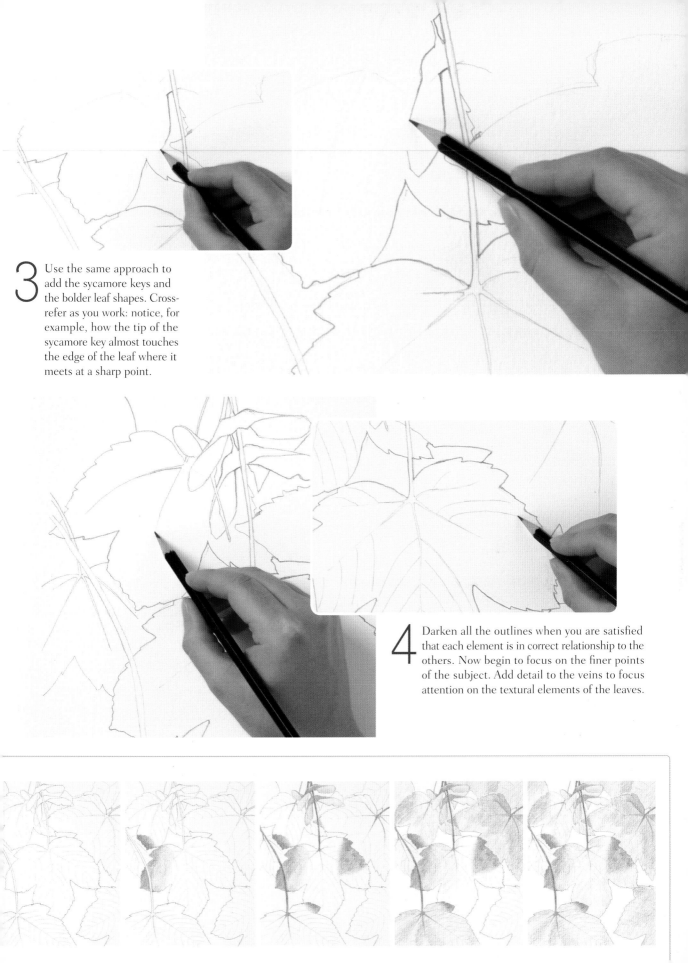

3 Use the same approach to add the sycamore keys and the bolder leaf shapes. Cross-refer as you work: notice, for example, how the tip of the sycamore key almost touches the edge of the leaf where it meets at a sharp point.

4 Darken all the outlines when you are satisfied that each element is in correct relationship to the others. Now begin to focus on the finer points of the subject. Add detail to the veins to focus attention on the textural elements of the leaves.

5 When all the lines are in place, use the side of the pencil lead to lightly shade in areas of tone where the leaves overlap. Start gently and then press harder in the places where the shadows are darker.

"The balance of positive shapes and negative space creates harmony."

6 Shade in the sycamore keys using the point of the pencil and pressing harder, because these have darker tones than those found on the leaves. Hatch the underside of the keys very lightly, to contrast with the darker tone.

7 Continue using the point of the pencil to add definition to the long, slender stems. Press hard to create the darkest tone here, lightening the pressure as the stems lead into veins. The stems are the heaviest structural element.

8 Balance the overall design by lightly shading all over the leaves. This harmonizes the structural and tonal elements of the composition, and contrasts with the unshaded negative spaces, to achieve a visually pleasing balance between the two.

Overlapping leaves ▶

The two-dimensional leaves help you to concentrate on negative space and outline. The clear, bold shapes of randomly overlapping leaves create a natural and simple pattern of form and space with which to work.

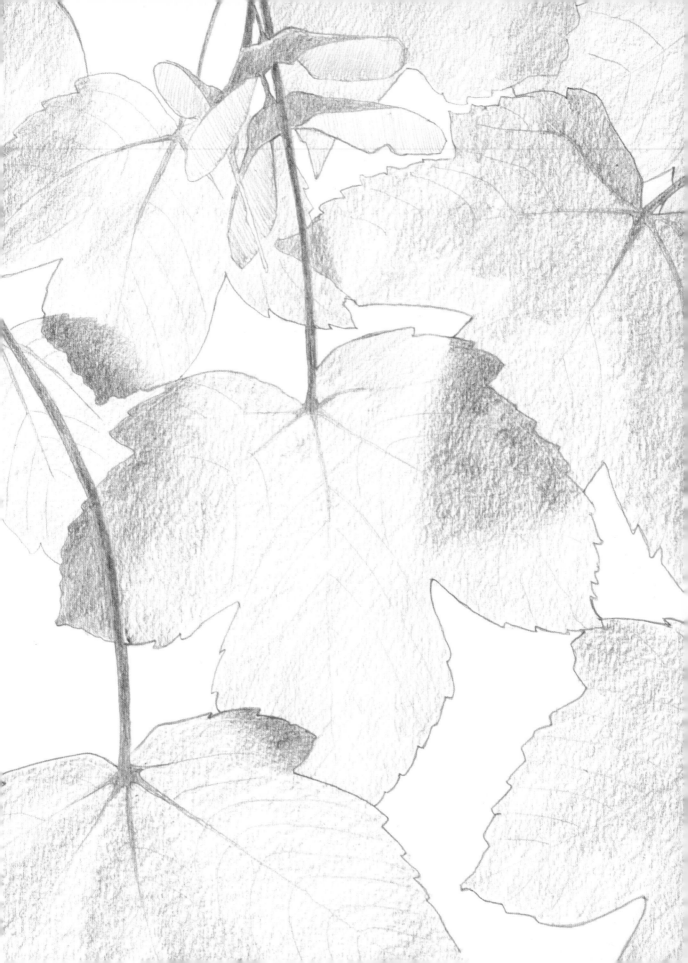

2 Books on a table

Varying the weight, quality, and nuance of line brings a drawing to life. But first you need to block out your composition, with the subject right in front of you, at eye level. This deceptively simple still life of books under natural light challenges your powers of observation. Take a few minutes to study how the books are arranged. You will need to take careful measurements, consider vanishing points, use negative space, and draw straight lines. Once the structure of the drawing is in place, you can start to explore different strengths of line.

EQUIPMENT
- 11 x 17 in, smooth white drawing paper
- H, HB, and 4B pencils
- Plastic eraser
- Sheet of letter-size paper

TECHNIQUES
- Measuring with a pencil
- Drawing geometric shapes
- Using negative space
- Thin and thick lines to show depth and form

1 Mark off the paper into thirds, using the HB pencil. Use a ruler to measure if need be. As you gain experience, this grid will become instinctive and the lines imaginary. For now, the grid will help you to position objects and place focal points.

2 Start with the focal point, the little book, and draw it on the bottom right third line. The spine of one upright book falls approximately on the opposite third. Use sketchy lines to build the composition rather than rubbing out mistakes.

3 Use the spine of the little book as your base measurement (*see p.20*). Calculate the length of the longer lines: the height of the upright books is about twice as long; the bottom book is about 3½ times as long, from corner to opposite corner.

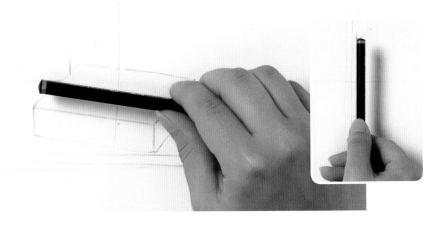

BUILDING THE IMAGE

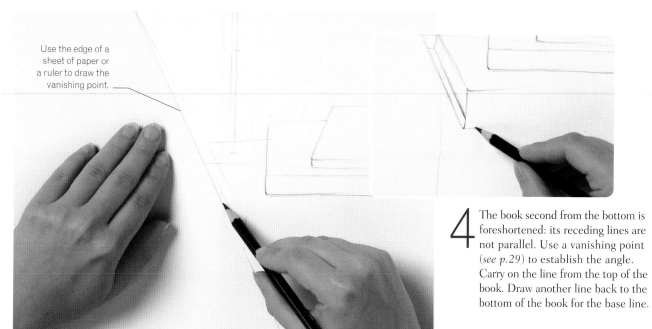

Use the edge of a sheet of paper or a ruler to draw the vanishing point.

4 The book second from the bottom is foreshortened: its receding lines are not parallel. Use a vanishing point (*see p.29*) to establish the angle. Carry on the line from the top of the book. Draw another line back to the bottom of the book for the base line.

"To help block in the structure, think of the books as a series of boxes or rectangles."

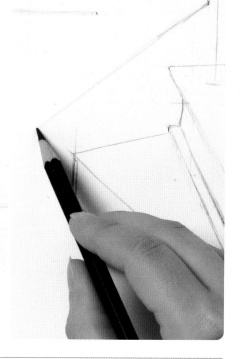

5 Draw the line of the table to anchor the objects. Draw the two bottom books. They create negative space that helps set the angle of the upright book. When you no longer need the vanishing points and grid of third lines, rub them out.

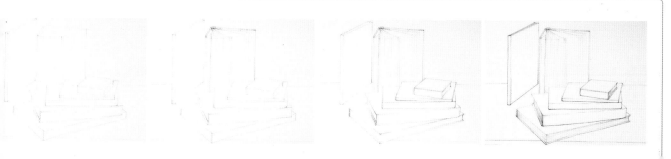

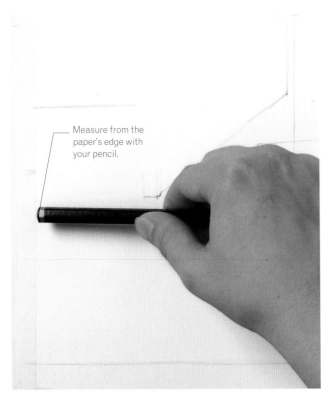

Measure from the paper's edge with your pencil.

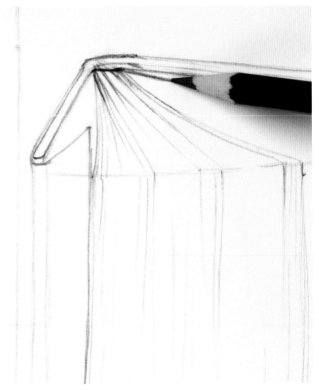

6 To draw the vertical line of the left-hand book, use the edge of the paper as a parallel. Mark the bottom of the line. Use your pencil to measure its distance from the edge of the paper. Mark the top of the line at the same pencil width.

7 Use the H pencil to start drawing the fine lines. Draw crisp, sharp lines to indicate individual pages of the upright book. Lighten the pressure as the lines come forward. Use the HB pencil to draw the covers of the books.

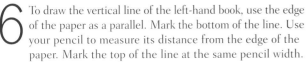

Confirm the best sketch lines with the HB pencil.

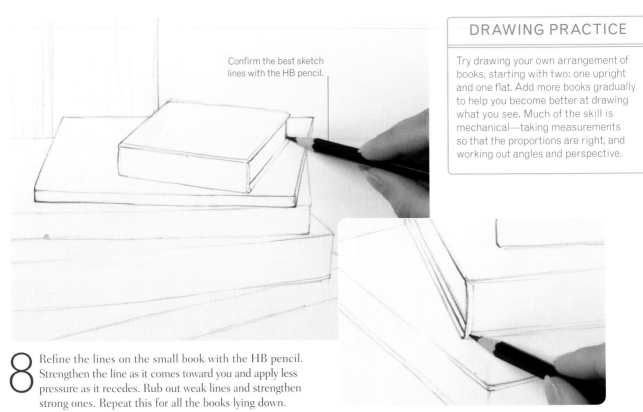

DRAWING PRACTICE

Try drawing your own arrangement of books, starting with two: one upright and one flat. Add more books gradually to help you become better at drawing what you see. Much of the skill is mechanical—taking measurements so that the proportions are right, and working out angles and perspective.

8 Refine the lines on the small book with the HB pencil. Strengthen the line as it comes toward you and apply less pressure as it recedes. Rub out weak lines and strengthen strong ones. Repeat this for all the books lying down.

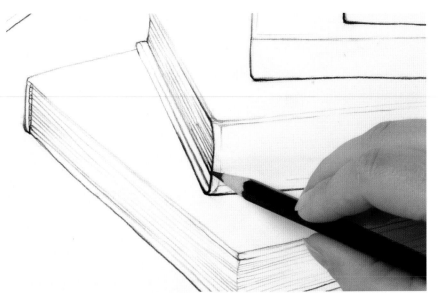

9 Use the 4B pencil for the darkest, thickest line of the closest books. Draw a heavy 4B shadow line underneath the book to ground it. Use the H pencil for the dash lines of the pages. Stabilize the table with a base line of 4B and verticals to suggest a leg and drawers.

▼ Books on a table

Drawing books will use all your technical skills and let you exploit the variety of lines that can be made with just three pencils. Shapes are repeated in the geometric composition: the arc of pages in the upright book echoes the fan of books lying down.

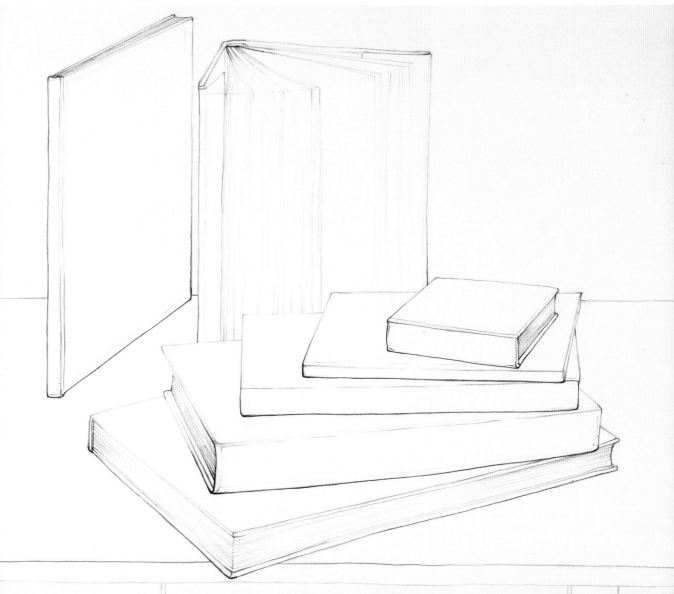

③ Country road

In this graphic landscape, the view, punctuated by a large house in the middle ground, makes use of leading lines to create an impression of recession from the foreground to the low hills in the distance. The banks along the road draw the eye along the sweep of pavement toward the house and beyond. Aerial perspective, whereby distant objects are drawn more faintly than they would appear in real life, has been used to increase the sense of depth. Charcoal, with its capacity for intense, velvety blacks as well as light grays, is ideal for the purpose.

EQUIPMENT
- 11 x 17 in Bristol paper
- Charcoal pencil
- Compressed charcoal stick
- Willow charcoal stick
- Soft watercolor brush

TECHNIQUES
- Using leading lines
- Using aerial perspective
- Hatching line
- Blocking in tone

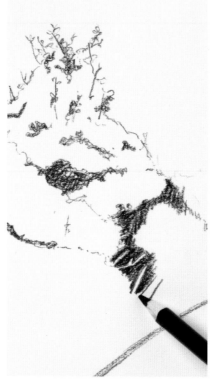

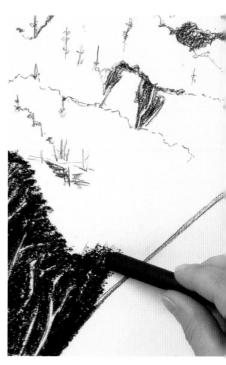

1 Using the charcoal pencil, sketch in the main lines of the scene to establish the composition. Only press very lightly with the pencil at this stage, as these first lines are intended as guides and you may find that you want to alter things later.

2 Once happy with the structure, think of tone. Squinting your eyes while looking at a scene helps to define areas of light and tone and see them as clear, bold shapes. Build up tonal areas with hatched lines using the charcoal pencil.

3 Switch to the compressed charcoal stick and strengthen the darkest areas on the roadside bank. Work around the indications of shrub stems, which remain as bare paper. Heightening definition here will bring the bank forward.

BUILDING THE IMAGE

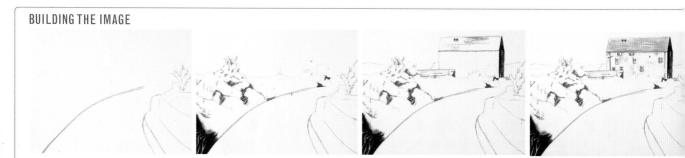

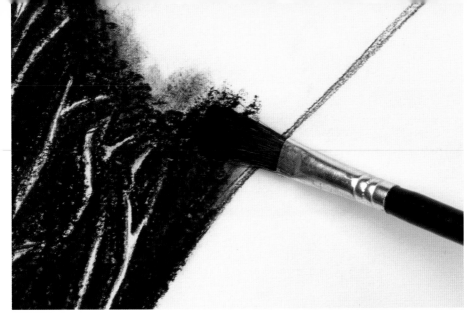

4 Soften any dark tones that seem to overpower the overall composition using gentle strokes with a soft brush. The brush also helps to smooth the charcoal evenly over the paper—and you can use it to remove any unwanted marks.

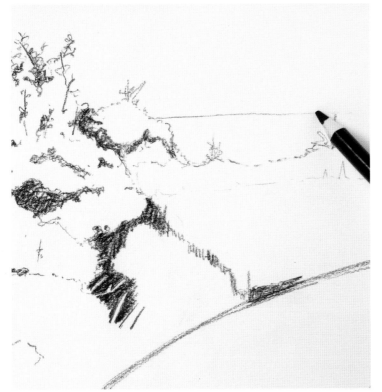

"Use the boldest lines in the foreground of a landscape."

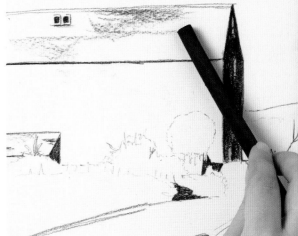

5 Lightly define the background details, using the charcoal pencil again. Keep the lines for the distant hills delicate so that they seem far away, compared with the intense charcoal foreground.

6 Add some tone to the roof of the building with the side of the willow charcoal stick. Areas of tone made with willow charcoal are lighter and softer than those made with compressed charcoal.

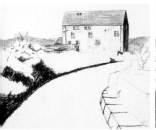
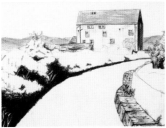
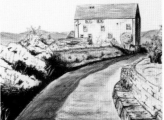
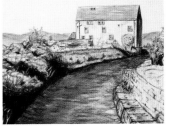

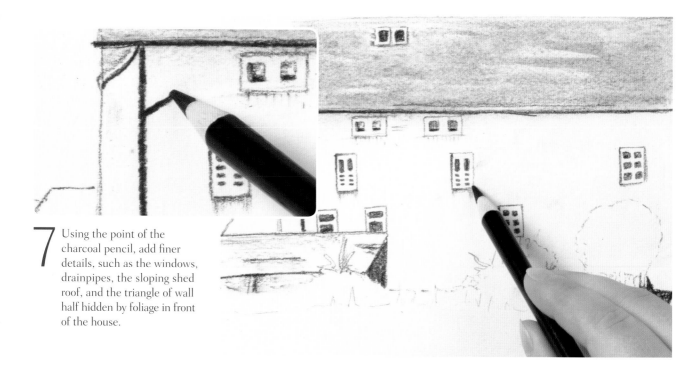

7 Using the point of the charcoal pencil, add finer details, such as the windows, drainpipes, the sloping shed roof, and the triangle of wall half hidden by foliage in front of the house.

8 Define the background hills in soft tones with gentle sweeps of the side of the willow charcoal stick. This hazy shading will create the effect of aerial perspective and give the landscape a sense of depth.

9 Using the charcoal pencil again, define the lines of the blocks on the right side of the road. The stone- and brickwork bring a strong sense of recession to this side and a structural element echoed in the house beyond.

LEVELS OF DETAIL

Charcoal is a good medium for landscape, as you can work in detail with the pencils and in broader swathes with willow and compressed sticks. You need to include enough detail to engage viewers' attention, but leave some things to the imagination.

10 Build up tone in the road by drawing gentle horizontal strokes with the willow charcoal held on its side. Let the paper show through where the light falls; this also helps to make the sidewalk stones stand out.

▼ Country road

Achieving a smooth progression from foreground to distance is one of the challenges of landscape drawing. Aerial perspective helps, particularly if the landscape has features such as a road or river to lead the eye into the scene.

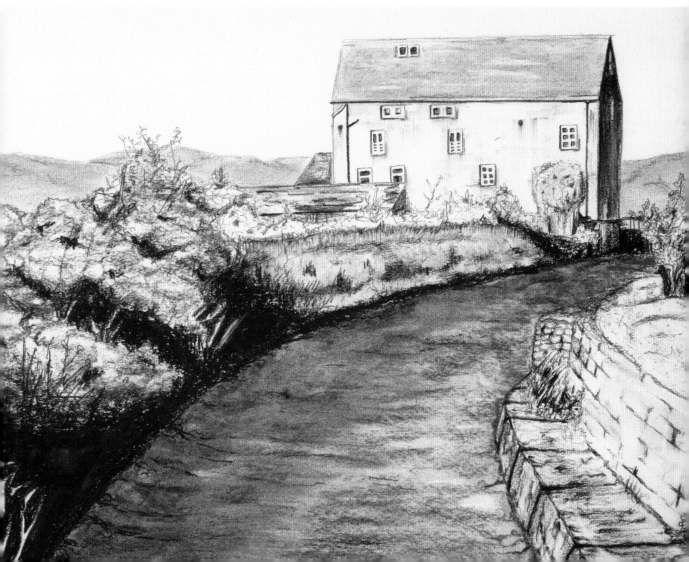

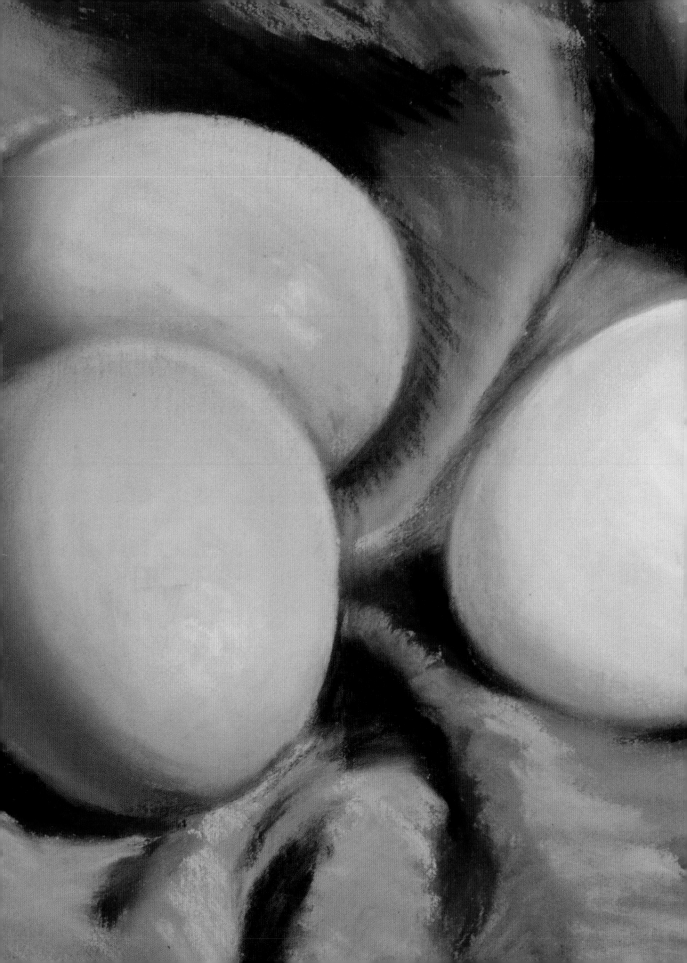

Tone

"Use light and
shade to create
depth and volume."

Light and dark

When you are sketching outdoors, you work under natural light, whether it is sunny or overcast, summer or winter, midday or twilight. Indoors, you have more control. Artists' studios traditionally face north to provide a constant light. Using artificial light, however, allows you to take your time and forget about changing levels of light. Showing how light falls and using tone to create shadows and highlights, makes everything you draw, whether objects, people, animals, or landscapes, look three-dimensional.

THE EFFECTS OF LIGHTING

A single bright light creates a contrast of light and shade that accentuates the form of things. A movable light such as an anglepoise lamp provides strong directional light. The play of light varies depending on where you place the light. You can use the direction of lighting to alter the mood of a drawing. Indoors, natural lighting is more gentle and diffused than artificial lighting.

FRONTLIGHTING

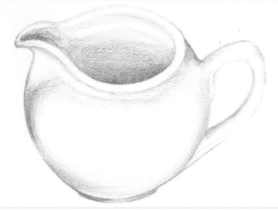

When an object is lit from the front, it looks bleached out, like a face photographed using just flashlight. Although pale, the object is rimmed in shadow, like the jug above.

SIDELIGHTING

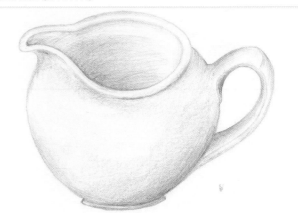

Often the best lighting for a still life, sidelighting strengthens the contrast of light and shade and shows form well. The transition from light to shade may be gradual or sharp depending on how bright the light source is.

BACKLIGHTING

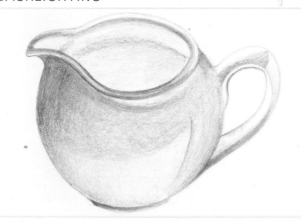

When an object is backlit, it is in shadow, often with a halo of light around it once you add background. Outdoors, drawing subject matter against the sun creates the same effect and can look dazzlingly effective.

THREE-QUARTER LIGHTING

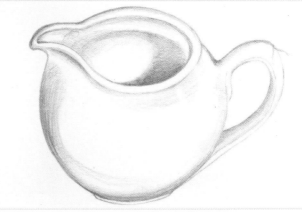

The light is shining from the right foreground, over the artist's shoulder, so both the inside and outside of the jug have a mixture of light and shadow. Three-quarter lighting is flattering for portraits.

USING TONE

Strongly contrasting areas of tone are eye-catching, whereas more subdued tone fades into the background. In black-and-white drawings, dark shading on white paper looks striking, while gray tone recedes. You can use this knowledge to add depth and solidity to your drawings. Combine tone with line or use it on its own. Charcoal and pastel are good for tonal drawing.

Stippling

There are many ways to apply tone and one of them is stippling—dots. How closely you space the dots and how big you make them varies the density of tone.

Tone in color

Colors are dark or light in tone, just as pencil or charcoal are. One way to make a color look paler is to apply less pigment, as on the right of the drawing above. Squinting your eyes helps you see how light or dark colors are in relation to each other.

Line or tone?

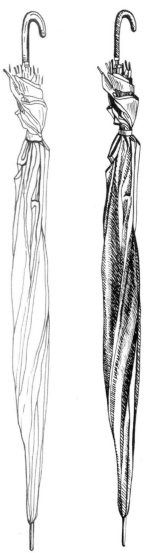

The first umbrella is drawn entirely in line; the second one is drawn in line with hatched shading to show clearly the folds of the fabric. Both have their strengths: which you prefer is a matter of choice.

Drawing part of a picture in detail and leaving the rest of it sketchy creates a focal area of interest. Here, the sparing lines of bedding lead the eye to the head of the sleeping figure. The vertical of the corner and hatching scribbled onto a section of wall give context. Note how a single pencil is used to create different depths of tone.

Selective tone

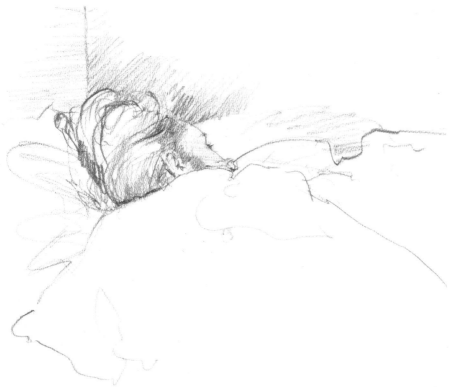

Gallery

Use of tone, with or without line, conveys solidity and form in drawing and comes to the fore when working in black and white.

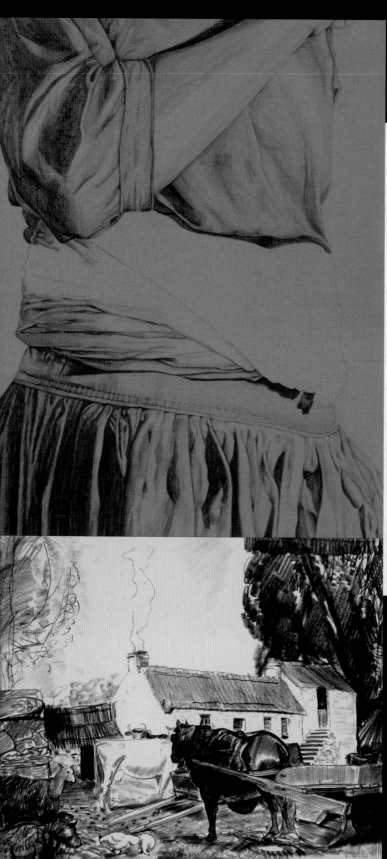

◀ **Fabric study**

Creative cropping of the figure focuses attention on to the penciled fabric. Light catches the ridges of material under the waistband, while folds retreat into shadow, making the texture tangible. *Liane Holey*

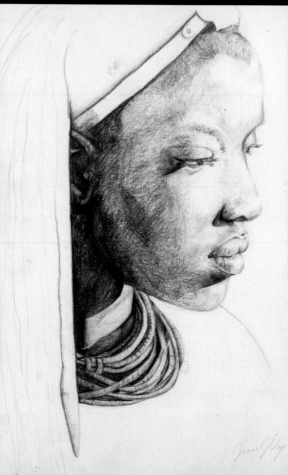

▲ **Profile of a young woman**

Bathing the features in light reinforces the thoughtful expression of the model. The pencil tone deepens from the cheeks to the neck and hairline and stands out against the white headgear. A sliver of crosshatching indicates the cheekbone. *Liane Holey*

◀ **Farmyard**

Conté crayon tone and composition work hand in hand as the dark shape of the horse leads the eye toward the white form of the cow, pointing up the steps to the house and ushered back down by the darkly hatched tree, set against the pale sky. *George Wesley Bellows*

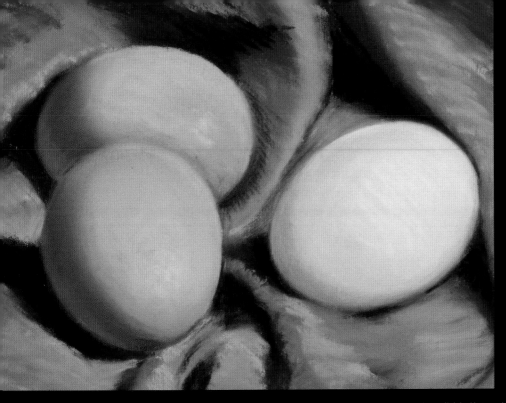

◄ Eggs

Tone is equally important in color. Soft chalk pastels capture the matte surface of egg shells, with the lilac of the fabric reflected in the shadows. *Jennifer Mackay Windle*

▼ Seated nude

Light falls on the woman's breasts, stomach, forearms, and thighs in this subtly erotic study. Bands of scribbled and blended tone in conté crayon are counteracted by a secondary light source illuminating the model's back. *Isabel Hutchison*

▼ En marche (Walking)

Conté crayon is a superb medium for purely tonal drawings. Haloed in light, the figure emerges from the background in the monochrome equivalent of the artist's dotted pointillist oil-paintings. *Georges Seurat*

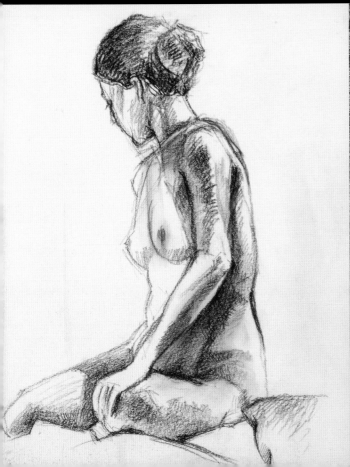

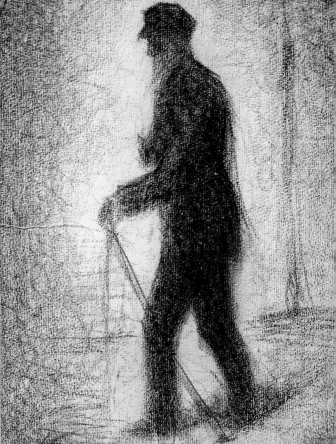

4 Group of shells

In this still life, hard and soft graphite pencils are used on mid-toned paper to capture the smooth and nubbly textures of a group of shells, and light and shade are emphasized to create the impression of solidity and depth. Working on textured paper with a slight tooth adds definition to the areas of tone and enhances the sense of three-dimensional form on the flat surface of the paper. To make the composition more interesting, the shells are strongly lit from one side by a single light, which casts dramatic shadows over the simple arrangement.

EQUIPMENT
- 8½ x 11 in peach-toned paper with a slight tooth
- Putty eraser
- 2H, H, B, HB, 2B, and 4B graphite pencils

TECHNIQUES
- Hatching lines to express tone and form
- Drawing out highlights with a putty eraser

1 Lightly sketch the outlines of the shells with the HB pencil, rubbing out any mistakes. Use the negative spaces between and around the shells to help define their contours and position them correctly. Strengthen the best lines with the 2B pencil.

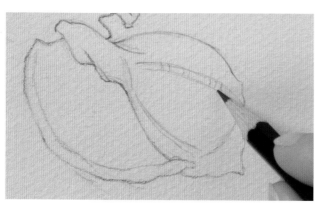

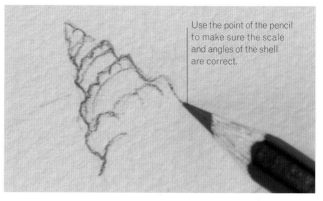

Use the point of the pencil to make sure the scale and angles of the shell are correct.

2 Add detail to the front shell with the HB pencil. Use light pressure to create delicate lines at this stage, so that you can rub out any lines that you are not happy with. Use your pencil to keep checking that the angles are correct.

3 Start to define more intricate details of pattern and structure with the 2B pencil, still keeping the pressure light so that you can change things if you like. Spend time getting the drawing stage right before you shade anything.

BUILDING THE IMAGE

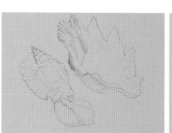
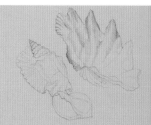

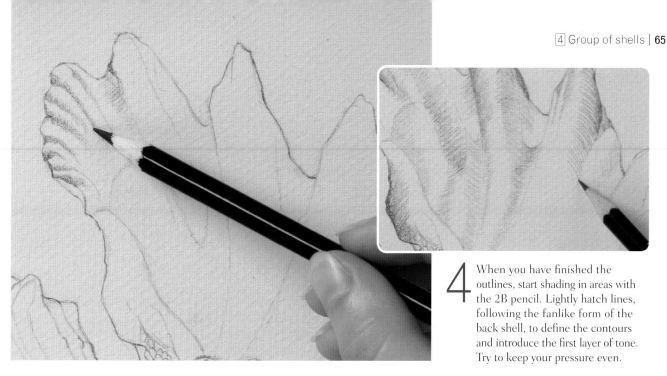

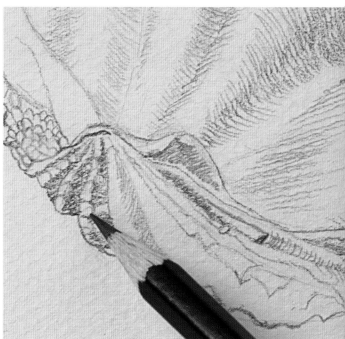

4 When you have finished the outlines, start shading in areas with the 2B pencil. Lightly hatch lines, following the fanlike form of the back shell, to define the contours and introduce the first layer of tone. Try to keep your pressure even.

"It is important to feel happy with the outline before adding detail."

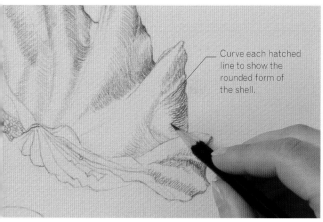

Curve each hatched line to show the rounded form of the shell.

5 Add another layer of hatched lines with the 2B pencil. Keep following the contours of the shell, but apply slightly firmer pressure where the shadows are darkest. Use the H pencil to add any sharper details.

6 Continue using the H pencil to define the intricate little ridges of the underside of the back shell. Switch to the softer B pencil to darken the areas of hatched tone between the ridges. This will seem to add depth to them.

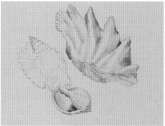
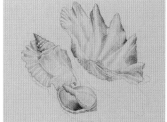
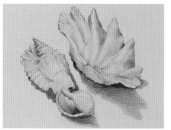

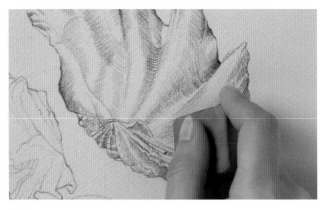

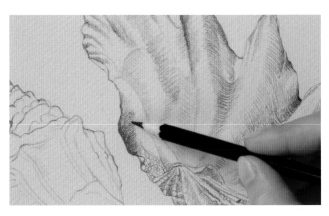

7 To model the shape of the large shell on the right, make gentle downward strokes along the ridges of the shell with the corner of the putty eraser. This will erase parts of the drawing and create areas of highlight.

8 To finish the shell, study it closely to see where the darkest shadows are, then strengthen these areas of tone by adding further layers of close hatching with the 2B pencil. The deep shadows provide a strong contrast with the highlights.

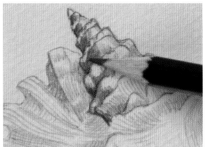

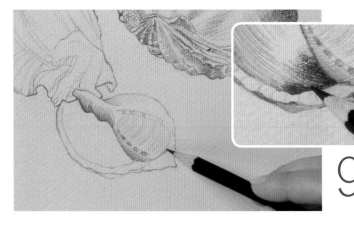

TIPS ON TONE

Squint your eyes when looking at your subject to help you see where the areas of light and shade are. When you add tone, place a piece of paper under your hand to stop you from smudging.

9 Complete the small shell in the foreground by adding regular hatched lines with the 2H pencil to model its form. Introduce darker shading with HB on the interior of the shell and use the 2B pencil for the darkest areas of shadow.

10 With the HB pencil, continue adding detail to the larger shell on the left, paying particular attention to its texture. Notice how the strong side lighting emphasizes the form of the shell and the tonal contrasts.

11 With the 2B pencil, gently work over the main body of the shell with crosshatching. This adds tone to the shell and helps to convey its uneven texture.

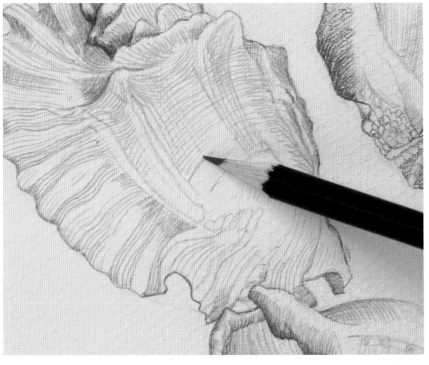

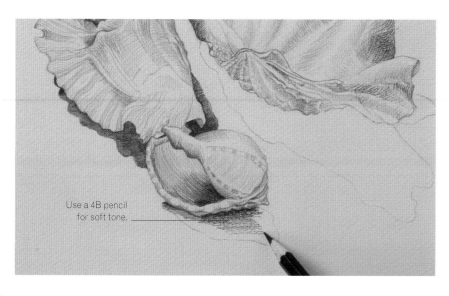

Use a 4B pencil
for soft tone.

12 Lightly draw the outlines of the shells' shadows with the H pencil. Shade in the darkest areas of shadow beneath the shells with the side of the 4B pencil. Use the 2B pencil for the areas of more diffused shadow.

▼ Group of shells

Simple hatching in a range of pencils has been used to make the shells look three-dimensional and give them texture. The dramatic side lighting has emphasized the contrast between light and shade and made the composition stronger.

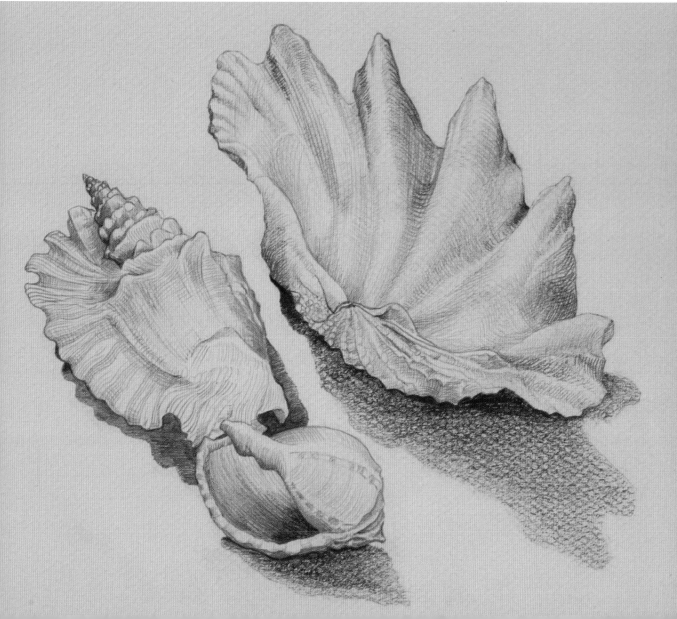

5 Portrait of a young woman

This monochrome study in conté crayon is drawn on tinted paper, which provides the mid-tone in the drawing. The portrait is drawn from a three-quarters viewpoint, perhaps the most interesting angle from which to view a face and common in traditional portraits. The main source of light is on the model's left, and there is a second light above her. The artist is looking up at the model and this low viewpoint, along with the strong contrast between light and dark tones, emphasizes the sculptural nature of the head and evokes a sense of drama.

EQUIPMENT
- Tinted pastel paper
- Black and white conté crayons
- Shaper
- Plastic eraser

TECHNIQUES
- Blending with a shaper, eraser, and finger
- Following the form of the subject
- Touching in highlights

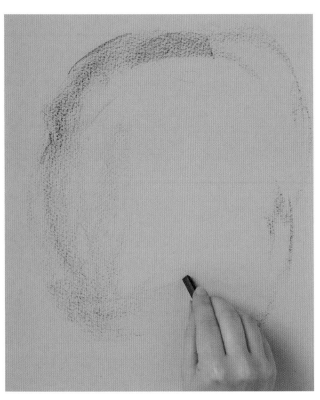

1 Lightly block in the shape of the head with the side of the black crayon. Working in faint tone rather than line will make it easier for you to fit the whole head onto your page. Make the left side of the face darker to show where the light falls.

2 Use the stick end of the shaper to measure from the chin to the bottom of the nose, the length of the nose, and the distance from the top of the nose to the hairline. Lightly mark the points you have measured in black line.

BUILDING THE IMAGE

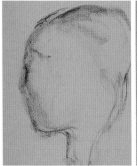
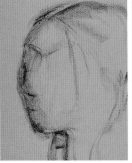
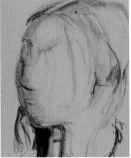
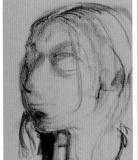
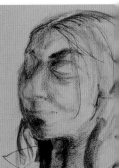

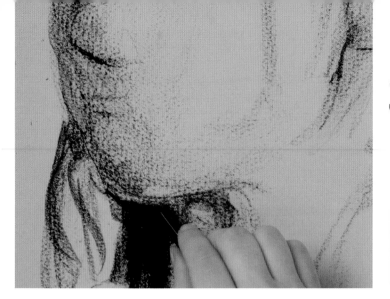

3 Draw the hair below the chin on the left side of the face. Work in mid-tone, pressing lightly until you are happy that it is in the right place, then work over it, strengthening the tone.

POSITIONING FEATURES

When you are at the same eye level as your model, the eyes will be halfway up the head in a portrait. Lowering the viewpoint, so that you look up at the model, affects the position of the features. Trust your eyes and your measurements and draw the eyes, nose, mouth, and ears exactly where you see them.

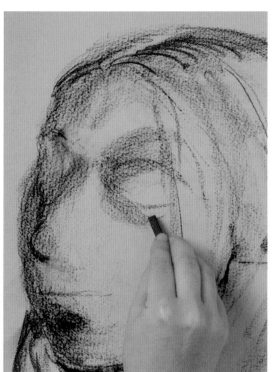

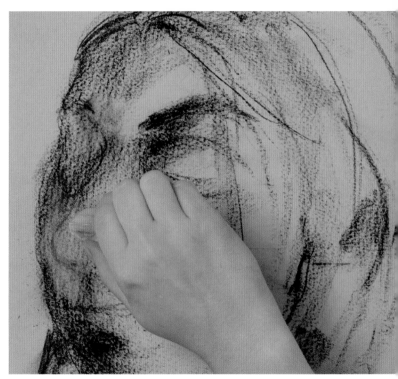

4 Use the point of the crayon to draw strands of hair that follow the shape of the head. Lightly indicate the curves of the eye sockets and cheeks, using the broad edge of the crayon.

5 Check that the distances from the mouth to the nose and the nose to the eyes are correct, as well as the distance from the top to the bottom of the head. Correct any mistakes by rubbing out the crayon with paper towel or the eraser.

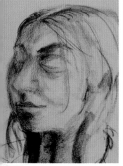
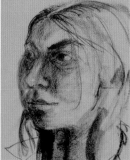
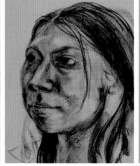
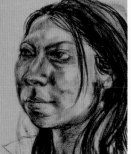
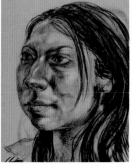

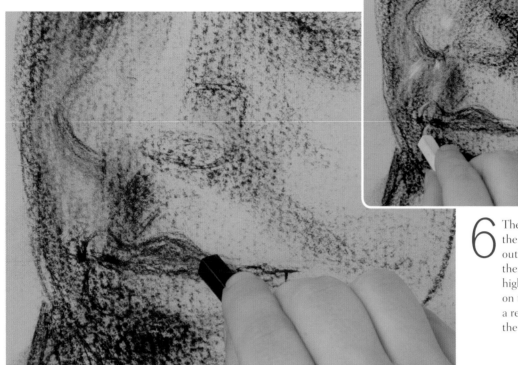

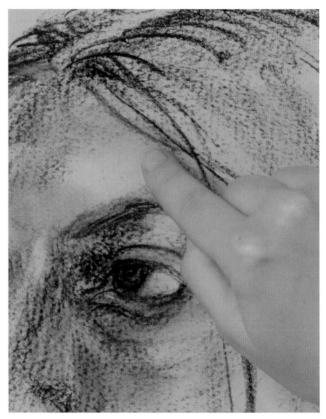

6 The mouth is about a third of the way up the face. Draw the outline of the lips in black, then use white to indicate the highlights below the nose and on the lips. The white will be a reminder, as you will add the highlights last of all.

"Taking away tone is as important as adding it."

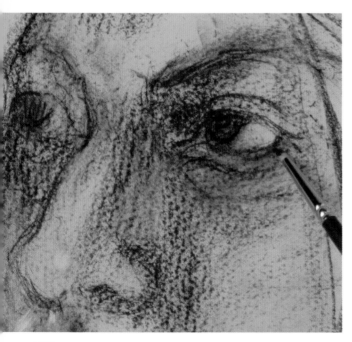

7 Draw the details of the eyes, the eyelids, and the eyebrows in black crayon. Use the shaper, which is like an eraser on a pencil, to blend in the different tones around the eyes. Rub the shaper clean on a paper towel.

8 Rub out a highlight on the forehead and smudge it with your finger to blend it in. Rub out and smudge highlights on the browbone and cheekbones in the same way. Now you have light tones, as well as dark and mid-tones.

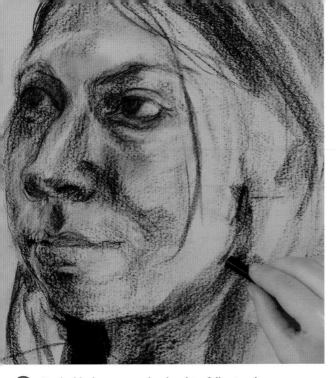

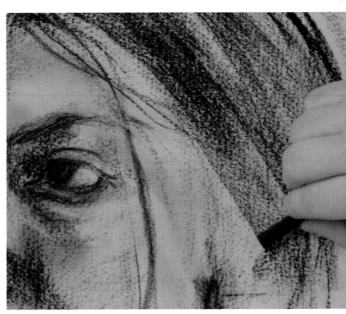

9 Stroke black crayon under the chin, following the contours of the face, to bring the head forward visually. Build up tone, using similar curved strokes rather than lines, to draw the areas of the cheeks and neck that are in shadow.

10 Use the black crayon on its side to block in the hair and add volume to the top of the head. Hair often moves, so leave most of the detail to the end. Start to refine tone, adjusting light and dark areas over the whole picture.

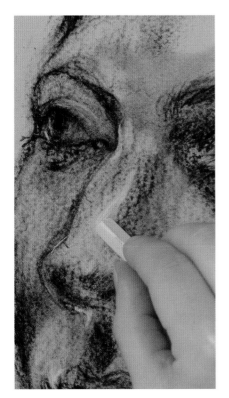

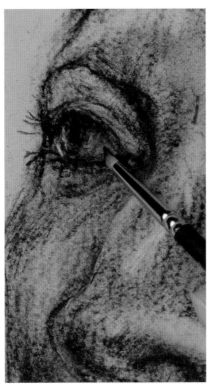

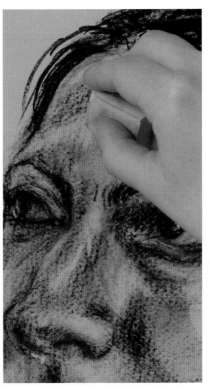

11 With the eraser, rub out the crayon tone down the bridge of the nose. Draw a highlight line down the nose. Dab a highlight just under the nose, halfway between the nostrils.

12 Use the shaper to adjust the details around the eyes. Rub out highlights above and below the eyes to indicate the eye sockets. Erase tone to create highlights in the whites of the eyes.

13 Use the eraser to get back to the bare paper for larger areas of mid-tone on the forehead. Lightly draw the eraser over the model's right cheek to adjust the tone. Keep checking where the light falls.

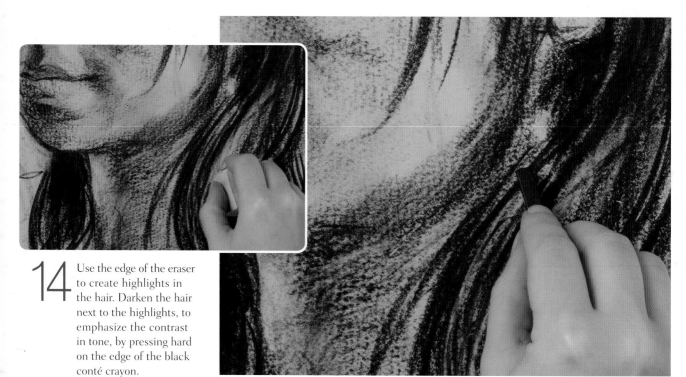

14 Use the edge of the eraser to create highlights in the hair. Darken the hair next to the highlights, to emphasize the contrast in tone, by pressing hard on the edge of the black conté crayon.

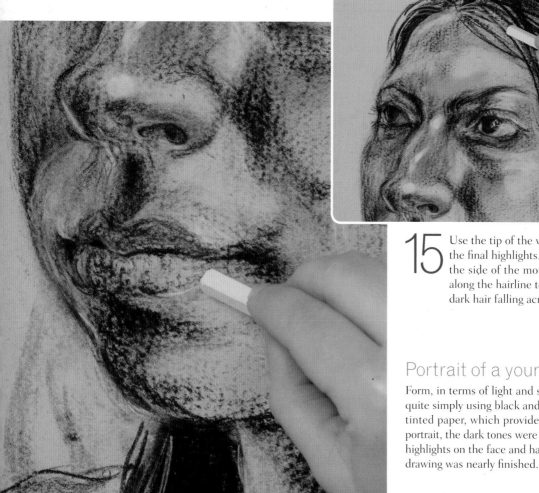

15 Use the tip of the white conté crayon to add the final highlights. Draw a fine line beneath the side of the mouth and nose. Draw lines along the hairline to form a contrast with the dark hair falling across the face.

Portrait of a young woman ▶

Form, in terms of light and shade, can be expressed quite simply using black and white conté crayons on tinted paper, which provides the mid-tone. In this portrait, the dark tones were established first and the highlights on the face and hair were added when the drawing was nearly finished.

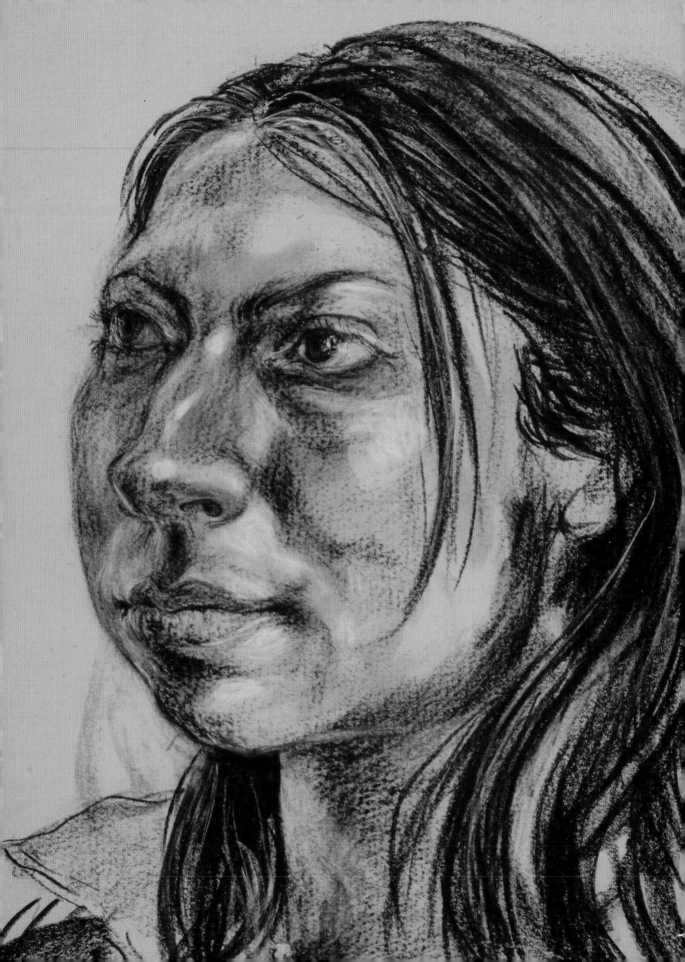

6 Parrot study

In this complex line drawing, a range of four technical pens is used to vary the density of line employed to draw the parrot's feathers and to produce a range of tones suggesting its underlying shape. Hatching, stippling, and even scribbled strokes are all used to great effect to depict the different types of plumage and the physical weight and form of the parrot's body beneath. Notice how the tones are built up gradually, after an initial pencil sketch, to convey the soft, plump mass that is an intrinsic characteristic of the subject.

EQUIPMENT
- 8½ x 11 in drawing paper
- HB pencil
- Technical pens 0.1, 0.3, 0.5, 0.7

TECHNIQUES
- Hatching and crosshatching
- Creating lines of different strength
- Stippling

"Light and shade are all you need to show nuances of texture and form."

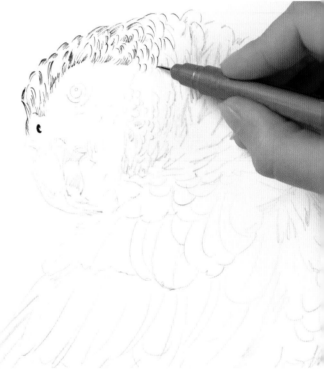

TECHNICAL PENS

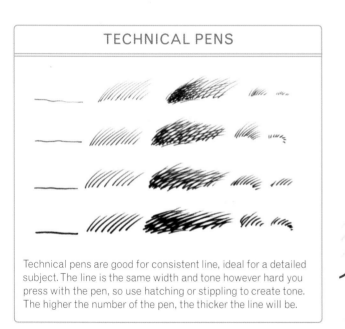

Technical pens are good for consistent line, ideal for a detailed subject. The line is the same width and tone however hard you press with the pen, so use hatching or stippling to create tone. The higher the number of the pen, the thicker the line will be.

1 Lightly sketch the outline of the bird and the contours of its feathers using the HB pencil. Starting with the head, use the sketch as a guide for your first ink marks with the 0.1 pen. Make small feathering strokes that follow the plumage.

BUILDING THE IMAGE

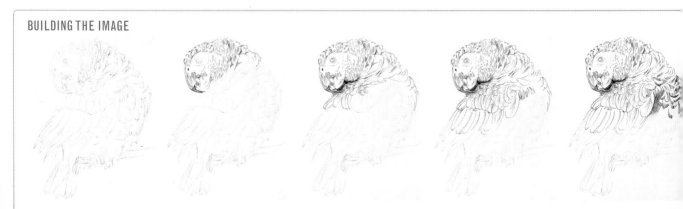

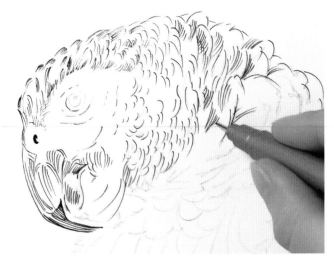

2 Using the same pen, hatch the first layer of shading, working downward from the head to the neck. Make the hatched lines closer together to increase the density of tone where necessary. Curve the lines to follow the contours.

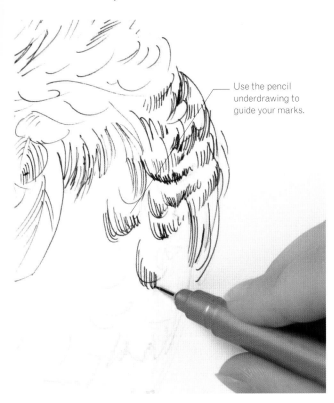

Use the pencil underdrawing to guide your marks.

3 Work methodically over the whole of the bird, following the natural downward growth of the feathers. Use small directional strokes with the 0.3 pen to draw the larger feathers on the back.

4 Create the smooth, curved appearance of the breast feathers by repeating the small downward strokes with the 0.3 pen, but hatching them closer together to strengthen the darker tones.

PENCIL FIRST

When doing a detailed pen drawing, make a sketch in pencil first. Pencil mistakes are easy to rub out, but pen marks are there to stay.

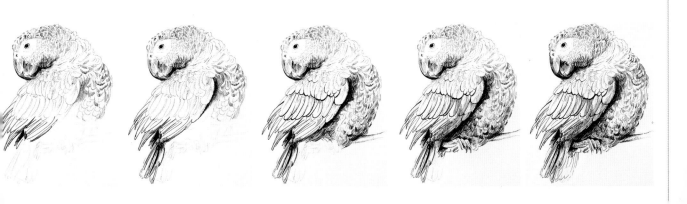

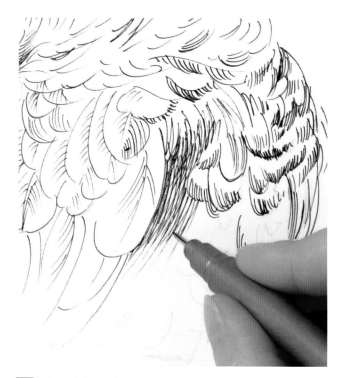

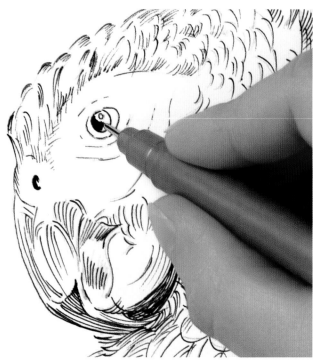

5 Start defining the area of shadow between the wing and the breast, using regular downward sweeping strokes with the 0.5 pen tip. This will be the darkest shadow in the picture.

6 Fill in the detail of the eye with the 0.3 pen tip but leave a spot of highlight—the white of the paper. The highlight enlivens the eye and makes it look shiny.

LIGHT OR DARK

The bare paper is a valuable foil to the pen marks when working in the consistent monotone of technical pen. It provides highlights and contrast.

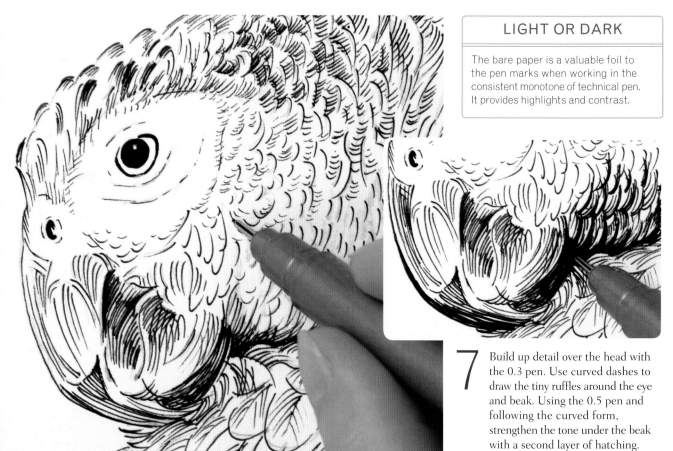

7 Build up detail over the head with the 0.3 pen. Use curved dashes to draw the tiny ruffles around the eye and beak. Using the 0.5 pen and following the curved form, strengthen the tone under the beak with a second layer of hatching.

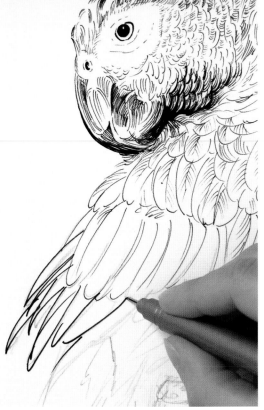

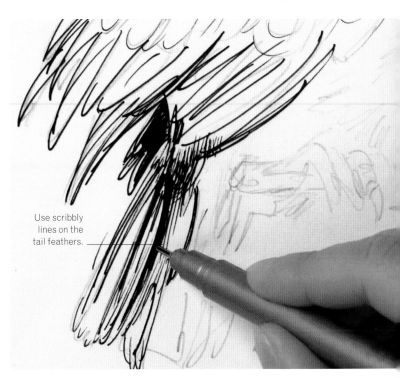

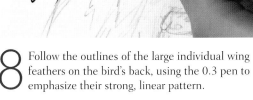

Use scribbly lines on the tail feathers.

8 Follow the outlines of the large individual wing feathers on the bird's back, using the 0.3 pen to emphasize their strong, linear pattern.

9 The tail feathers are more ruffled. Keeping your hand relaxed, hatch lines upward and downward with the 0.5 pen to depict the subtle variation of light and dark tone in this area.

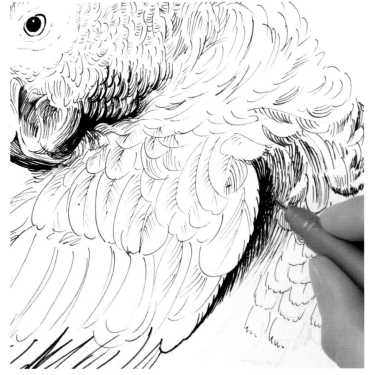

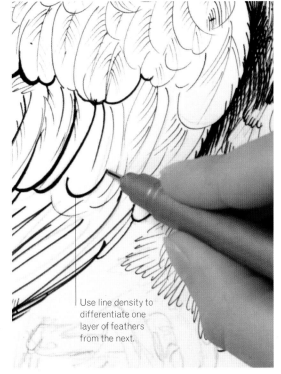

Use line density to differentiate one layer of feathers from the next.

10 Using the 0.5 pen, add a layer of crosshatching with the lines close together to strengthen the shadow under the wing. This dense shadow helps to bring the wing forward from the body.

11 Continue drawing the surface of the wing, boldly defining the contours of the individual feathers with the 0.7 pen. This will achieve the layering effect of the feathers on the wing.

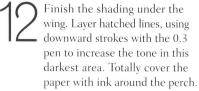

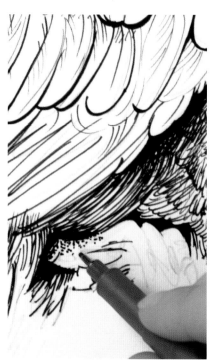

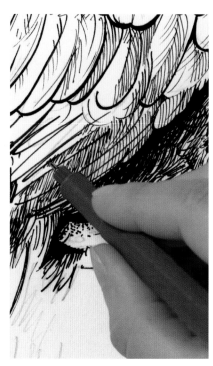

12 Finish the shading under the wing. Layer hatched lines, using downward strokes with the 0.3 pen to increase the tone in this darkest area. Totally cover the paper with ink around the perch.

13 Use a different technique of stippling (dotting) with the 0.3 pen to shade the perch and distinguish it from the bird. The closer the dots are placed together, the darker the tone.

14 Add small, regular, hatched lines to add tone to the feathers that are in shade, in this case on the bottom edge of the wing. This hatching will help to make the wing look as if it is curved.

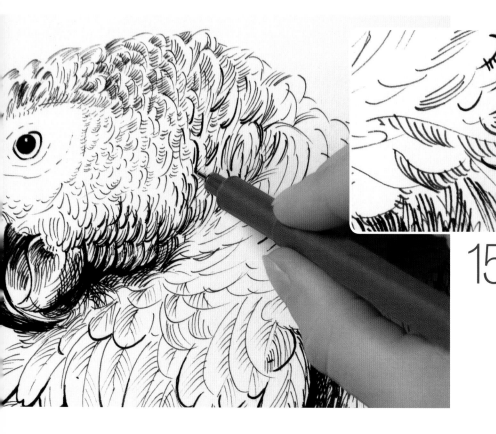

15 To finish the drawing, strengthen areas of fine detail where necessary. Emphasizing the contour line around individual feathers with the 0.7 pen helps to create the distinctive ruffled effect of the parrot's plumage.

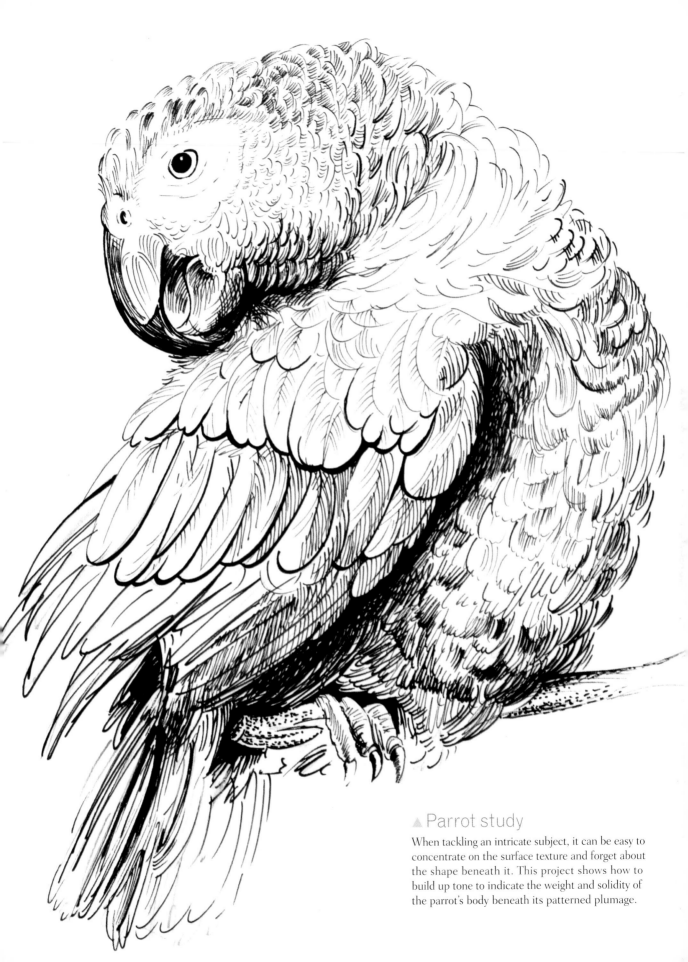

▲ Parrot study
When tackling an intricate subject, it can be easy to
concentrate on the surface texture and forget about
the shape beneath it. This project shows how to
build up tone to indicate the weight and solidity of
the parrot's body beneath its patterned plumage.

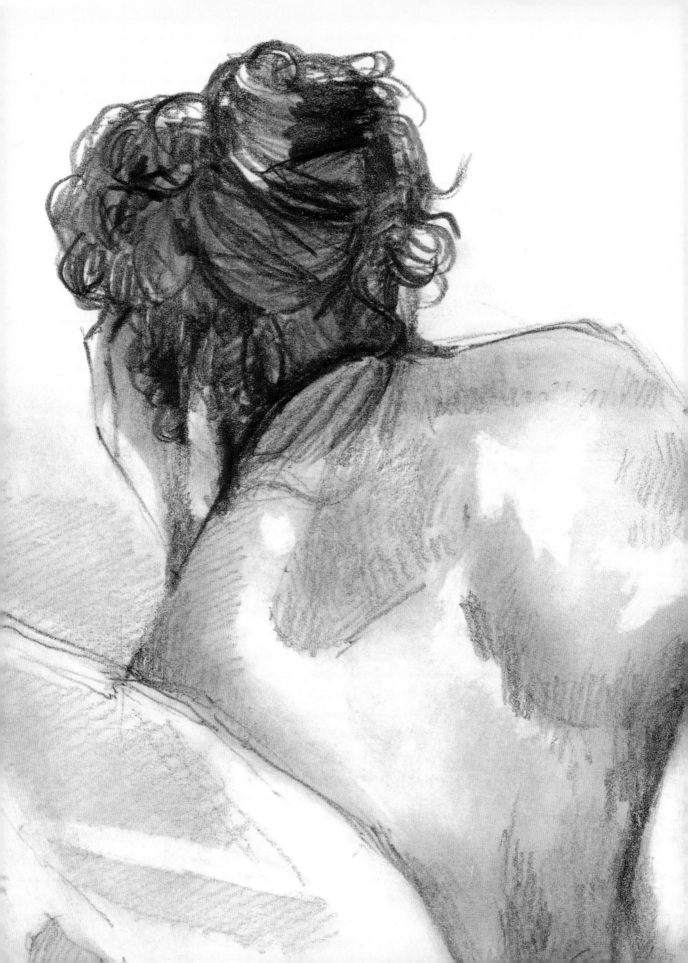

Composition

"Plan your picture:
consider the composition."

Planning a picture

When you set up a static arrangement such as a still life or portrait, you can organize the composition yourself. But even outdoors, when you find a composition in a landscape or moving subject, you need to think about what you place where and how all the parts of the picture work together. There are ways to make the picture interesting by leading the eye from one part to another without leaving the paper. Editing the scene, leaving things out or moving them, can help to make a more dynamic composition.

ARRANGING A STILL LIFE

There are do's and don'ts when it comes to still lifes. Include something with height, if necessary using a hidden platform. Avoid placing objects in a row. Instead, overlap objects to give depth but don't obscure small items with large ones. Think about negative spaces—the composition should look just as strong upside down, when the shapes are unrecognizable.

Choosing objects

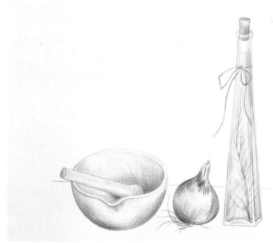

Although the objects are well chosen, providing a variety of sizes and shapes, placing them in a row puts the composition on one plane and is unexciting.

Zooming out

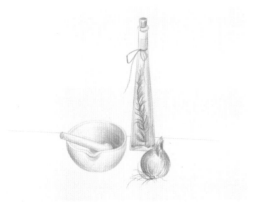

The still life looks stranded in a sea of paper: better to fill the page with the objects so that they sit comfortably in the size and format chosen.

Giving depth

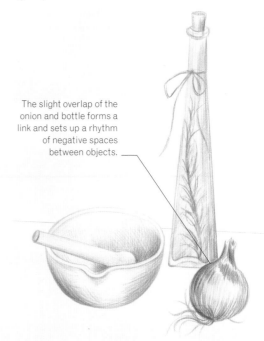

The slight overlap of the onion and bottle forms a link and sets up a rhythm of negative spaces between objects.

Moving the bottle to the back creates a strong composition with height and depth. The pestle leads the eye in and points toward the bottle.

Zooming in

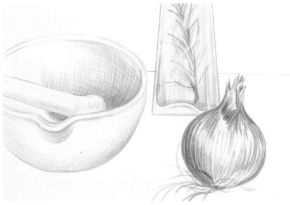

The elements fill the picture space. You do not have to include entire objects. Cropping can create interesting shapes and ideas.

CHOOSING A VIEWPOINT

After selecting the size and format of your paper, the next decision is what viewpoint to take. Scenes look reassuringly familiar and normal when you draw them at eye level. If you wish to look afresh, choose a low viewpoint (sitting on the floor or lying down), which makes things appear to loom over you. A high viewpoint makes objects look smaller.

Straight on

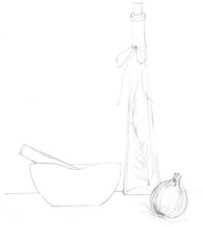

The safest, simplest view for you and the viewer is on your eye level when sitting down (or standing up if you prefer to draw this way).

Low viewpoint

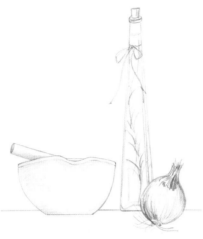

Looking up at your subject matter gives it extra importance. It can be effective for portraits, making a person look dominating and powerful.

Bird's-eye view

An overhead view gives you the chance to look into things rather than through them. Even a slightly high viewpoint reveals the tops of objects.

LANDSCAPES

To choose the best view of a landscape you often need to walk around, making several rough sketches to find the best composition. You are not taking a photograph—there is no need to record everything you see. Leave out any details that distract, and move things around to look balanced and pleasing to the eye. Framing the scene often creates an interesting composition.

The rounded arch draws the eye into the picture.

Diagonal hatching suggests the slope of hills in the background.

The archway opens a door into the drawing, especially with the road leading the eye to the houses. The brickwork gives the foreground impact, with a clear route to the middle ground and distance.

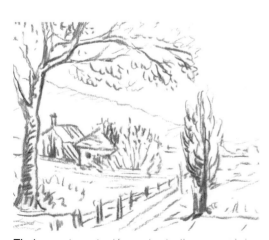

The trees make a natural frame, stopping the gaze wandering off the sides of the picture. The house tucks in cosily under the branches. The trees balance each other, but at the same time the asymmetry of the large and small trees is more stimulating to the eye than equal sizes.

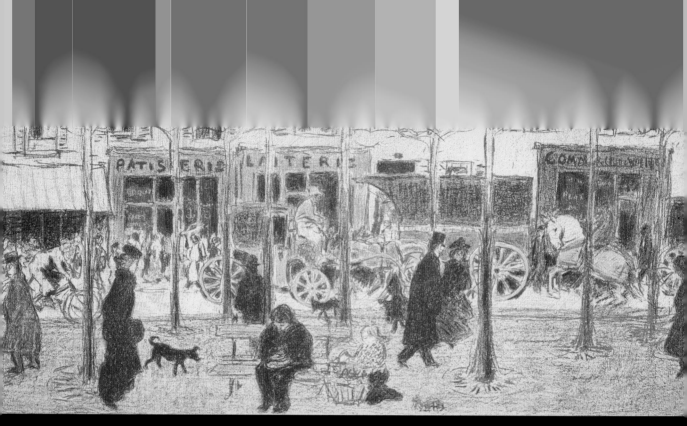

▲ Street scene in Paris

The truncated verticals break up the unusually wide format
—itself like a street—into a series of cameos. Color divides
the composition widthwise into two distinct horizontal bands.
Henri de Toulouse-Lautrec

▼ Nude study

Working on the diagonal creates dynamism even in a static pose.
In a figure, such a composition creates foreshortening so that the
foot is represented as larger than the head. Soft pencil shading
puts a sheen on the curves of the body. *Isabel Hutchison*

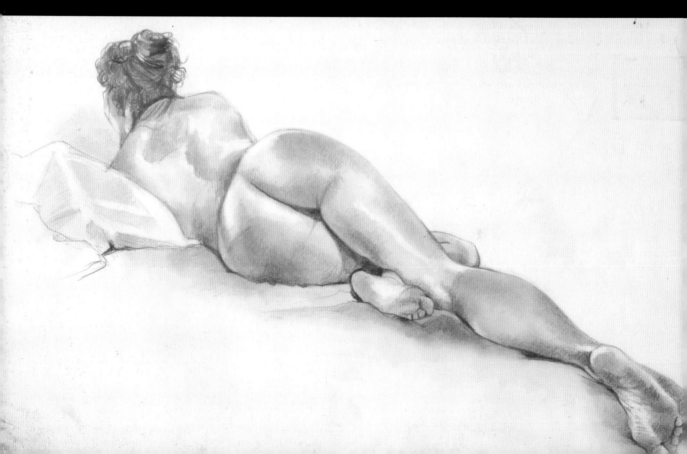

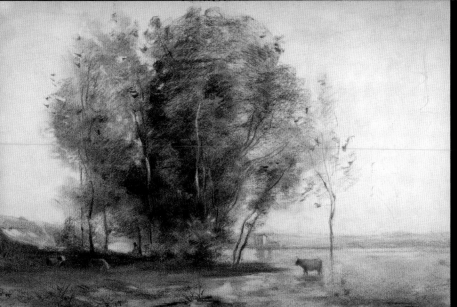

◀ Landscape with cow

Charcoal creates a soft and silvery scene in which the central tree mass dominates. The spindly tree on the right makes a frame for the cow, which leads the eye to the figures scattered under the tree. The building just visible on the far shore balances the cow and creates a sense of distance. *Jean Baptiste Camille Corot*

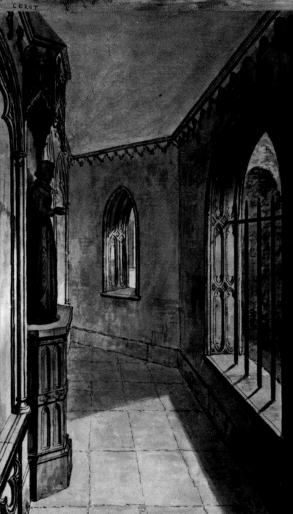

▲ Hallway at Strawberry Hill

Lines of perspective lead the eye along the flagstones and arouse curiosity as to what is around the corner. The statue in a recess and the window across from it frame and balance the composition widthwise. *Horace Walpole*

▲ Hare

The serenity of a centrally placed image in pencil is enlivened by the diagonal of the hare's back, turned head, and ears. The triangle formed by the animal solidly grounds it despite only a suggestion of context. *William Morris*

7 Kitchen still life

These household items were chosen for their bold, simple shapes, and were arranged in a group so that they overlap. The resulting layers create a sense of depth, and help focus the eye on the relationships between the different shapes. The bottles' straight sides contrast with the rounded casserole, the focal point, which in turn echoes the curves of the lemon squeezer. The use of complementary colors, orange and blue, describes the objects' reflecting surfaces and enlivens and unifies the picture. Well-planned composition and color go hand in hand.

EQUIPMENT
- 11 x 17 in textured pastel paper
- Willow charcoal stick
- Blue, green, yellow ochre, dark brown, terracotta, and white chalk pastels
- Fixative
- Clean rags or paper towel

TECHNIQUES
- Arranging a still life with height and depth
- Blending pastels with rag and finger

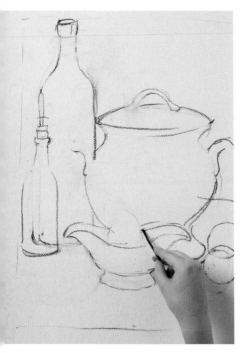

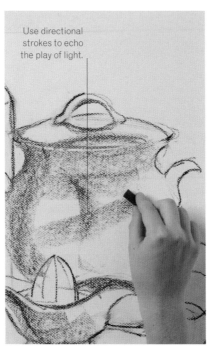

Use directional strokes to echo the play of light.

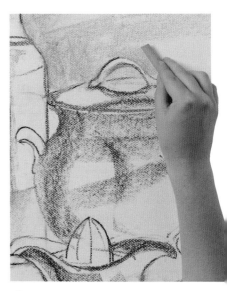

1 Starting with the largest object, the casserole, start drawing the outlines in willow charcoal. Note the different ellipses on the casserole, the base of the bottles, and the lemon squeezer. Keep the outlines light so that you can alter them easily if necessary.

2 Shade in the darkest areas of tone on the bottles, casserole, and lemon squeezer, using the side of a blue chalk pastel. Follow the curving forms of the objects. Half-close your eyes if necessary, to make it easier to see the areas of dark tone.

3 Repeat this process with the areas of lightest tone, using yellow ocher and light green to introduce some color contrast to the still life. Work over the background as well as the objects, as this is an integral part of the composition.

BUILDING THE IMAGE

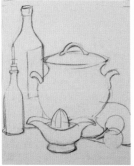
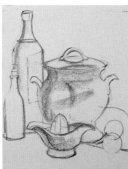
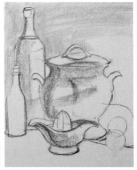
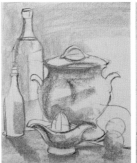
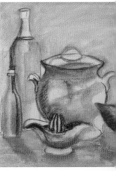

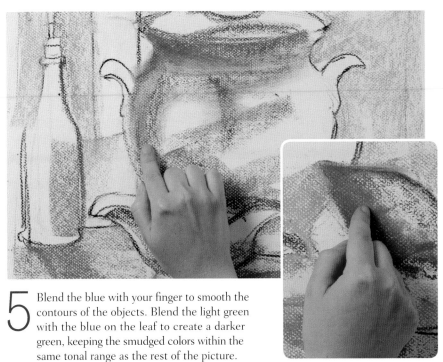

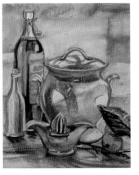

4 With the dark and light tones established, add a mid-tone in terracotta. With three basic tones in place, the objects start to look solid and weighty.

5 Blend the blue with your finger to smooth the contours of the objects. Blend the light green with the blue on the leaf to create a darker green, keeping the smudged colors within the same tonal range as the rest of the picture.

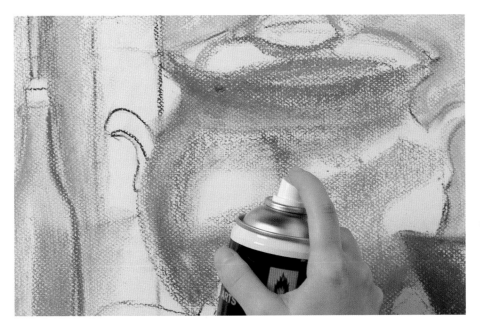

KEEPING CLEAN

Always wash your fingers or wipe them on a clean rag in between smudging one area of pastel and the next, so that you don't make the colors muddy.

6 Spray a light layer of fixative over the picture. This will prevent the pastels from smudging and prepare the surface for the next layer of pastel you apply.

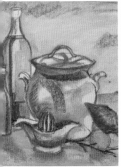
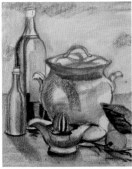
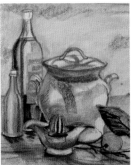
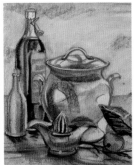
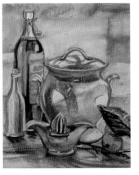

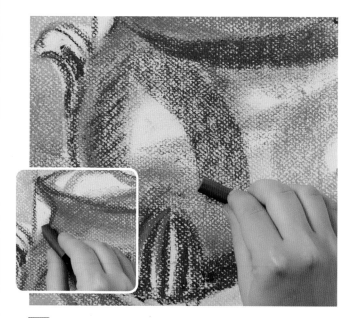

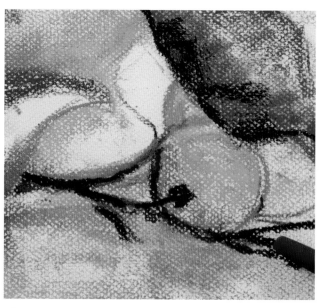

7 In blue, strengthen the outlines to make a feature of the negative space and to separate the objects from the background. Use the pastel on its side to emphasize the contrast in tones and create a pattern of repeated shapes.

8 Use the tip of the dark brown pastel to draw the angles of the twig, working over blue to make a strong line. Notice how the straight lines of the twig echo the sides of the bottles, sandwiching the curves of the objects in the center.

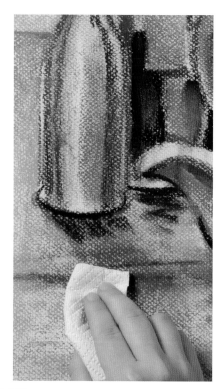

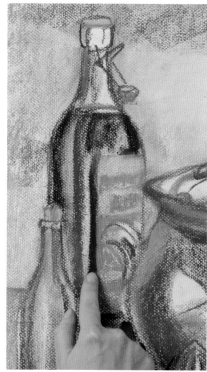

11 Use the tip of a white chalk pastel to add definition to the brightest areas of highlight on the reflective surfaces of the objects.

Kitchen still life ▶

Drawing a small group of everyday objects allows you to focus on their shape and form. Overlapping them is an easy way to make the picture look three dimensional. By treating the background and the objects as a whole, the picture is unified and a sense of depth is created.

9 Use a clean rag or a paper towel to blend and soften areas of dark tone that would otherwise appear too overpowering. Let the texture of the paper show through the pastel by building and blending layers lightly and gradually.

10 Work over the surface with your finger to blend areas of tone and give the objects a soft, smooth texture. Wash your finger in between colors. Leave some areas unblended so that the picture stays fresh and lively.

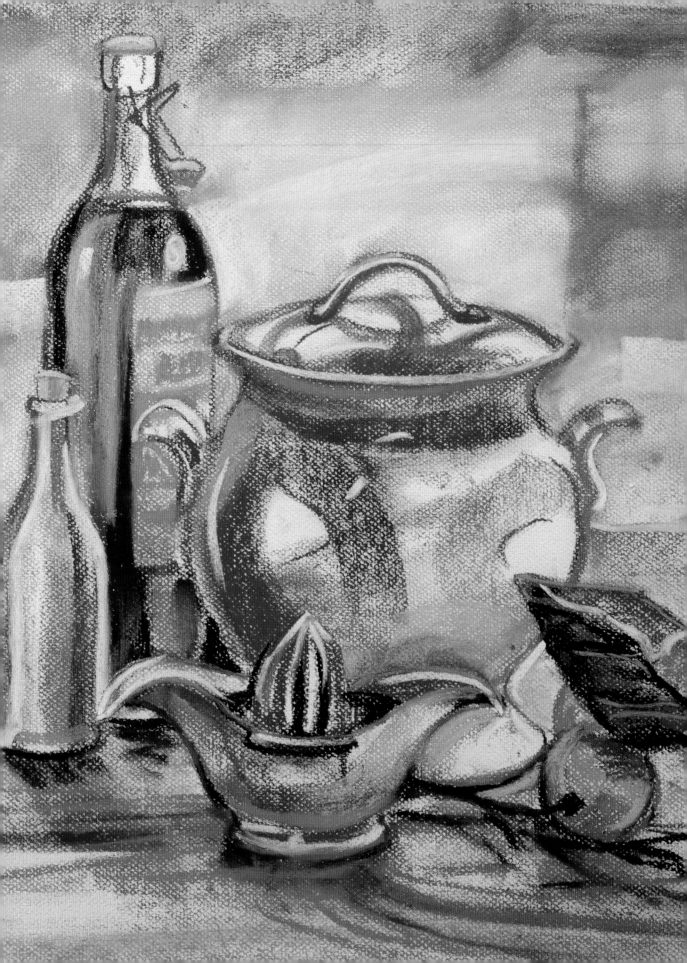

8 View of a watermill

In this attractive pencil drawing, the main elements of the composition are organized around the focal point, the watermill in the distance. The horizontal band of buildings leading toward the mill and the line of the water's edge draw your eye into the picture and create a powerful feeling of depth. After making thumbnail sketches, this viewpoint has been selected because the arch of the bridge and the railings frame the scene like an oval window, increasing the sense of perspective and focusing your attention on the watermill.

EQUIPMENT

- 11 x 17 in medium-weight drawing paper
- B and 2B pencils
- Plastic eraser
- Sharpener or knife

TECHNIQUES

- Using a viewfinder
- Measuring angles with a pencil
- Framing a scene
- Hatching and crosshatching

1 Turn the sheet of paper to landscape format and lightly sketch in the main shapes of the bridge and buildings beyond, using the B pencil. Only press lightly at this stage.

2 If necessary, hold the pencil up as for measuring (*see p.20*) to assess the angles of the building roofs. When you have sketched the main elements, stand back and check that everything is in the right place, then strengthen the lines.

BUILDING THE IMAGE

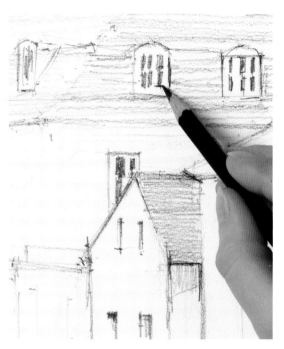

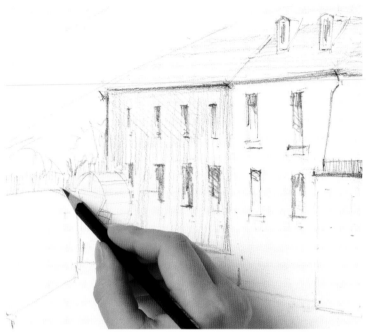

3 Still using the B pencil, start to build up the first layer of tone on broader areas with light hatching. Use the sharp point of the pencil lead to draw the finer details in the windows.

4 Continue using soft hatching for shading and the sharp point for detail over the entire drawing, keeping the tones light. Keep the drawing sketchy so you can make changes—it can be worked up later.

5 Use the side of the pencil lead to create long vertical lines of hatching that describe the pillar on the bottom left, and to add light tone and emphasize the vertical direction of the buildings on the right.

6 Shade the posts of the railings, pressing a little harder with the pencil. Use crosshatching to darken the tone and help suggest the rounded form of the railings.

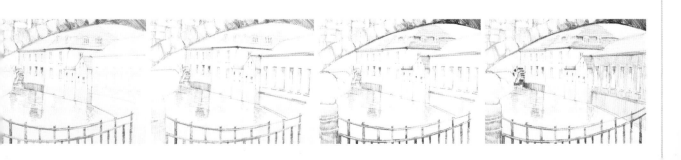

7 Shade the supporting bricks in the bridge using strokes in different directions to convey their rough-hewn texture. Leave some of the bricks bare for added impact. Draw the brickwork forming the bridge's arch in the same way.

"Quick hatching in different directions is good for creating texture."

8 Use the 2B pencil to shade in the vertical reflections of the buildings in the canal. Apply a spiral scribble of shading over the top, varying your pressure on the pencil to capture the variety of light and dark tones.

9 Still using the 2B pencil, strengthen the darkest shadows by pressing a little harder. Keep your pencil leads sharp throughout. Using a knife rather than a pencil sharpener enables you to create a longer lead that is good for shading.

10 Complete the picture by drawing attention to the focal point. Sharpen the tip of the 2B pencil, then strengthen and darken the details of the watermill.

▼ View of a watermill

This drawing focuses the eye on an interesting, though distant, focal point: the watermill. The unusual top and bottom frame creates a striking composition and the buildings lead the eye along the river. The variety of lines and textures of the architectural features combine to create a sense of depth.

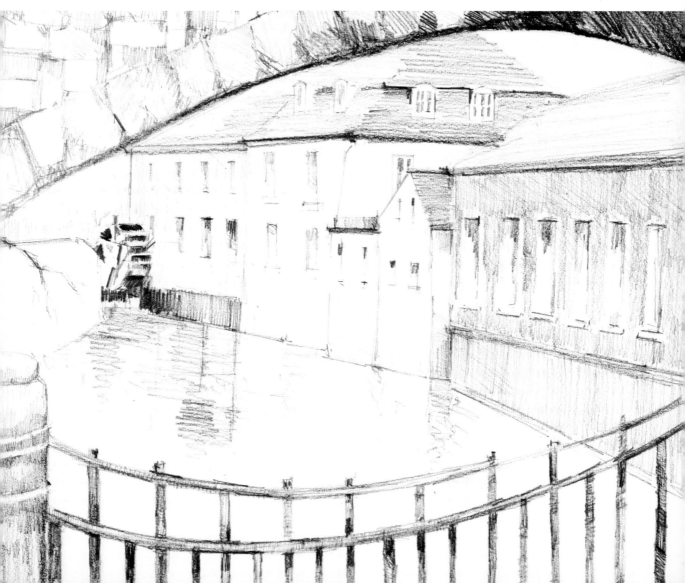

9 Lounging figure

Composition and planning are the key to successful life drawing. Here, after making four quick sketches, a simple but imposing composition has been chosen as a base for a longer study. The figure has been placed centrally, dividing the paper vertically from the head, through the torso, and down through the left leg, then horizontally through the right arm and right leg to create a crosslike composition. In the final drawing, dark tones in charcoal have been used in conjunction with highlights drawn out with an eraser to create a powerful image.

EQUIPMENT
- 11 x 17 in drawing paper
- Pencil
- Willow charcoal stick
- Compressed charcoal
- Putty eraser

TECHNIQUES
- Foreshortening limbs
- Smudging tone

QUICK POSES

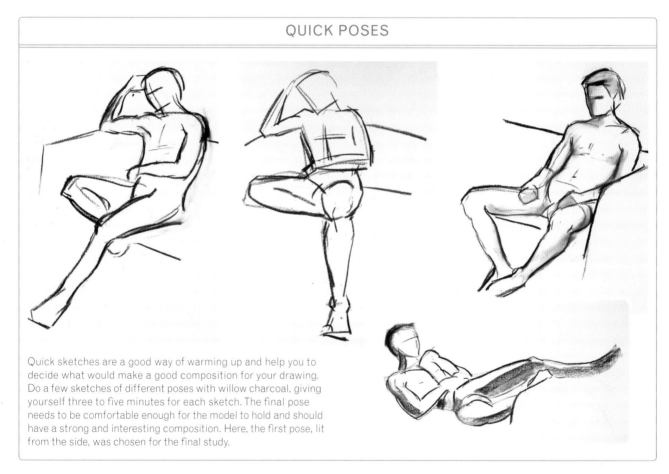

Quick sketches are a good way of warming up and help you to decide what would make a good composition for your drawing. Do a few sketches of different poses with willow charcoal, giving yourself three to five minutes for each sketch. The final pose needs to be comfortable enough for the model to hold and should have a strong and interesting composition. Here, the first pose, lit from the side, was chosen for the final study.

BUILDING THE IMAGE

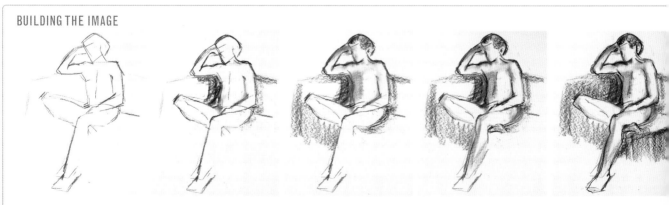

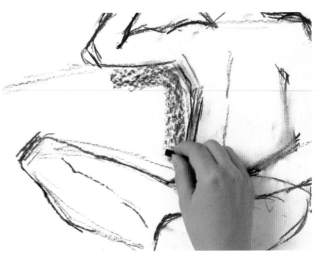

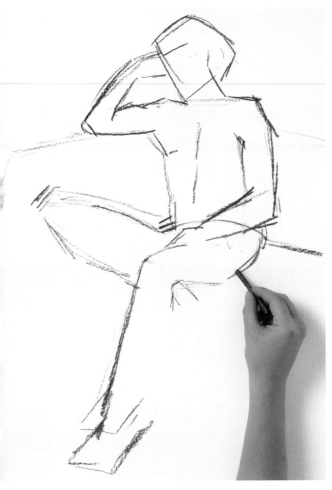

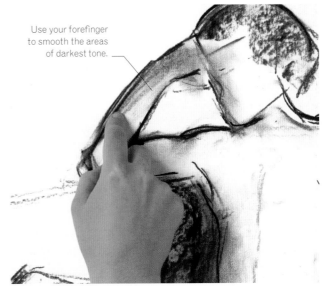

Use your forefinger to smooth the areas of darkest tone.

2 Draw the spaces between the different parts of the body to help position the arms and legs. When you are satisfied that they are in the right places, use the willow charcoal on its side to shade in the negative spaces around them.

1 Use a pencil to take measurements (*see p.20*) and mark key points on the figure, so you get the proportions right and can place it on the paper without cropping off the head or the foot. Sketch the outline of the figure with willow charcoal.

> "Marking key points on the figure first helps you to position it on the paper."

3 Identify the dark areas of tone on the figure. Gently smudge the outline of the drawing, following the direction of the arms and legs with your finger. The smudged tone creates the first layer of shading and a sense of solid form.

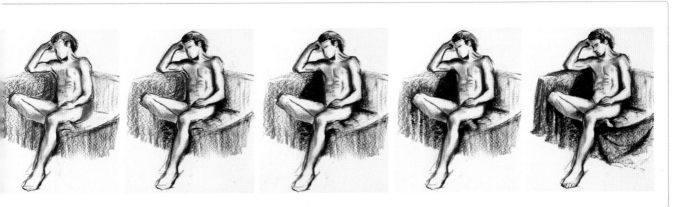

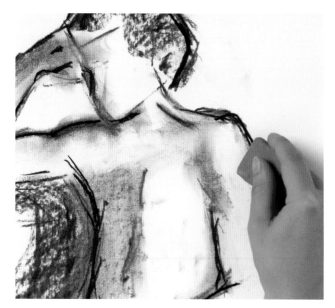

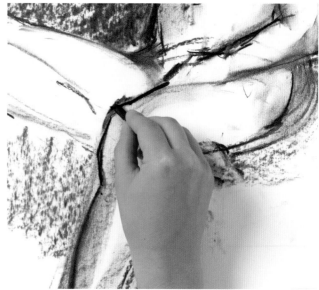

4 Now look at the main highlighted parts of the figure. Holding the putty eraser at a slight angle, press on it gently to draw broad areas of highlight out of the charcoal tones. Rub the putty eraser clean on a piece of scrap paper.

5 Go over the outlines of the figure with the point of the willow charcoal stick, constantly checking back to the life model. Use broken lines around the knee, to vary the outline to suit the weight distribution of the figure.

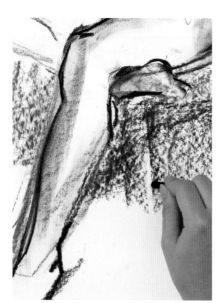

6 Start blocking in areas of tone on the seat to stop the figure from appearing to float in space. Make regular, light, downward strokes with the side of the willow charcoal stick.

7 Add tone to define the groups of muscles, smudging with your finger to keep the drawing soft. The tonal areas are all relative—as you darken one area, you see where another one needs to be strengthened.

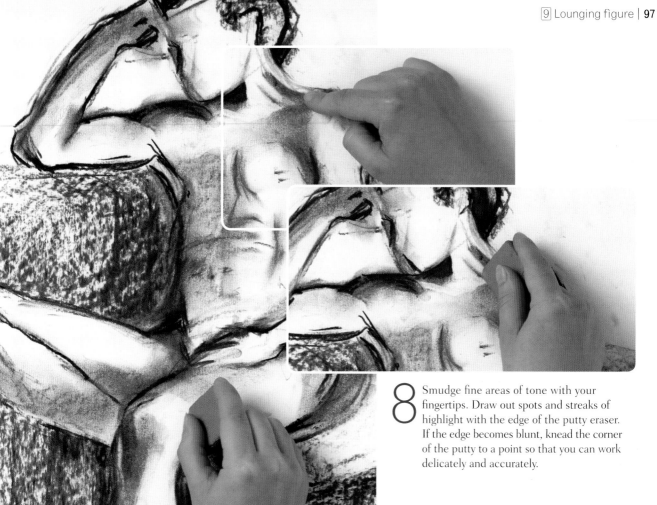

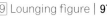

8 Smudge fine areas of tone with your fingertips. Draw out spots and streaks of highlight with the edge of the putty eraser. If the edge becomes blunt, knead the corner of the putty to a point so that you can work delicately and accurately.

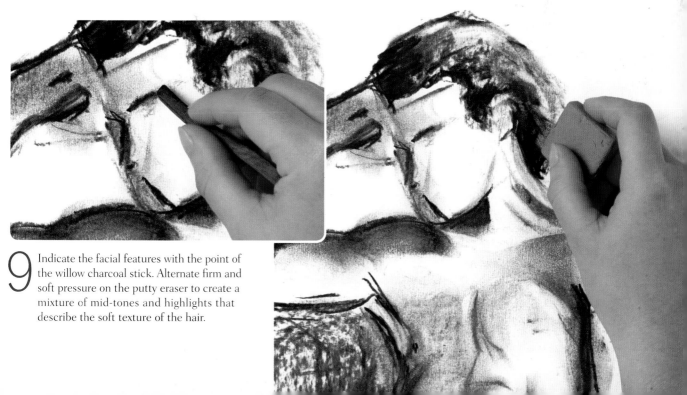

9 Indicate the facial features with the point of the willow charcoal stick. Alternate firm and soft pressure on the putty eraser to create a mixture of mid-tones and highlights that describe the soft texture of the hair.

10 Use the compressed charcoal, which is denser and blacker than the willow, to strengthen the darkest areas of tone. Increasing the contrast between light and dark tones creates a greater sense of depth in the drawing.

SIDE LIGHTING

The pose chosen for this drawing is strongly lit from the side. Side lighting creates deep shadows, which emphasize the muscular structure of the body in a nude figure study.

11 Use the compressed charcoal sparingly to draw hatched lines that follow the smooth, curved form of the lower leg and shoulder. This makes the figure seem more three dimensional and strengthens the areas of darkest shadow.

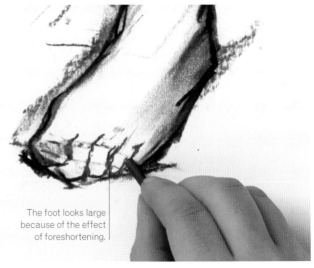

The foot looks large because of the effect of foreshortening.

12 Use the more delicate willow charcoal stick to refine the eyes, nose, and mouth. There is no call for huge detail, as the facial features need to be consistent with the broad treatment of the body and limbs.

13 Stand back and assess the drawing, adding finishing touches such as the lines separating the toes on the front foot. Ground the foot with a smudged shadow along the inside of it and behind the heel.

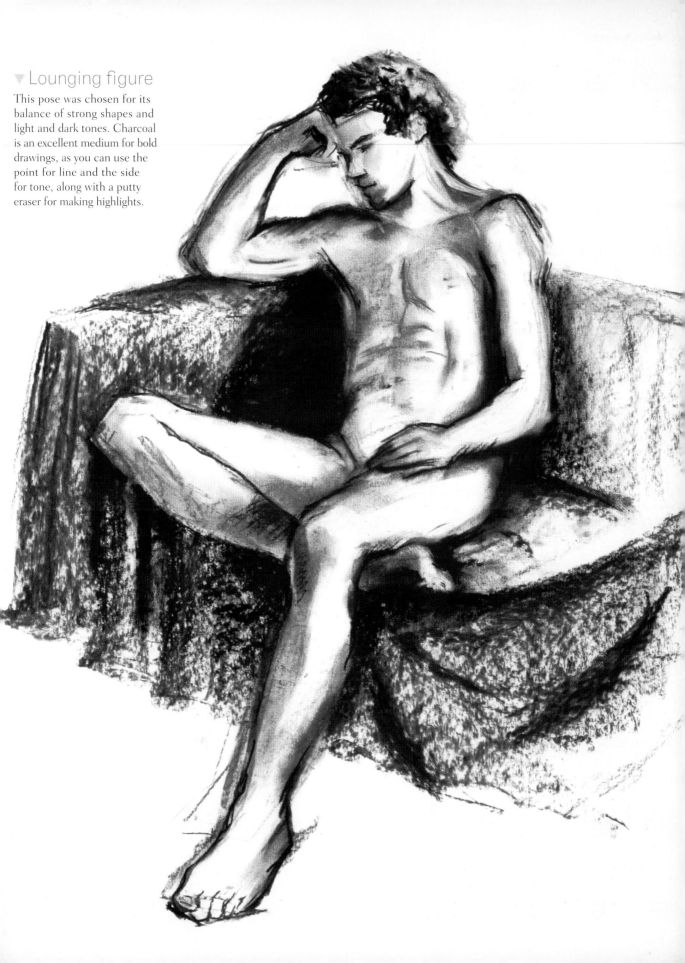

▼ Lounging figure

This pose was chosen for its balance of strong shapes and light and dark tones. Charcoal is an excellent medium for bold drawings, as you can use the point for line and the side for tone, along with a putty eraser for making highlights.

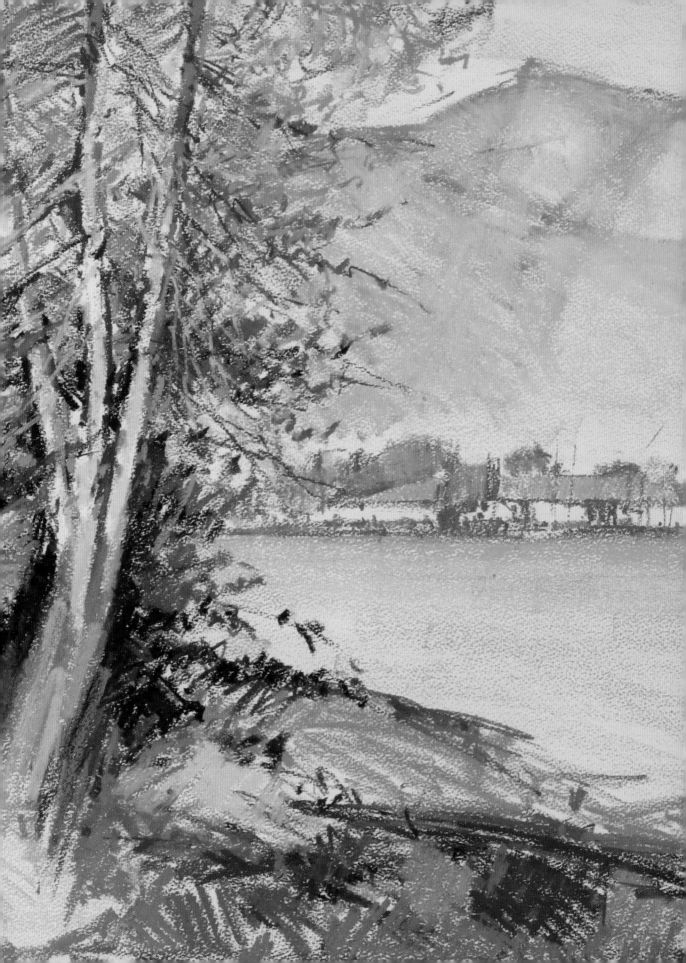

"Be selective with colors to create a vibrant picture."

Vibrant color schemes

Both pastels and colored pencils come in a huge range of colors because, unlike paints, you cannot mix them before you apply them to the paper. Tempting as it is to use all the colors, pictures are often more successful with a limited choice.

Bright color stands out all the more for being used judiciously. As with composition, what you leave out is as important as what you put in. And every color is affected by the others on the paper: the scheme needs to work as a whole.

WARM AND COOL COLORS

The colors of sun and fire—reds, yellows, and oranges—are described as warm. And the colors of sea and ice—blues—are known as cool. Warm colors seem to leap forward in a drawing. Cool colors appear to go backward into the picture. You can use this knowledge of warm colors advancing and cool ones receding to add distance and balance.

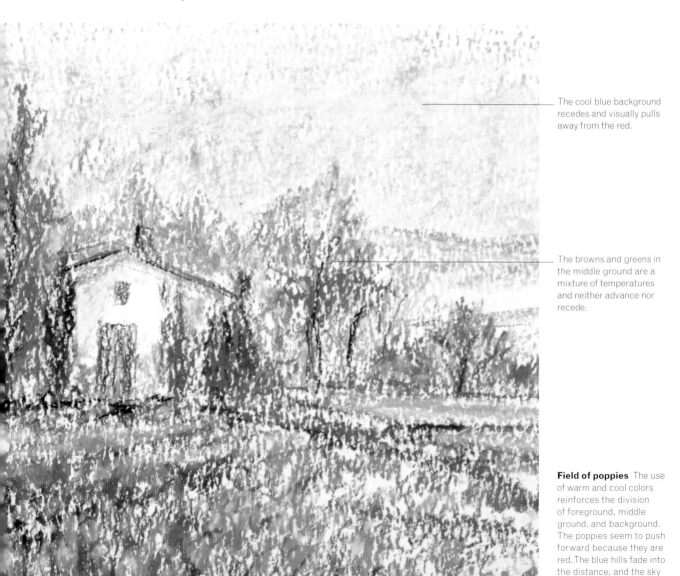

The cool blue background recedes and visually pulls away from the red.

The browns and greens in the middle ground are a mixture of temperatures and neither advance nor recede.

Field of poppies The use of warm and cool colors reinforces the division of foreground, middle ground, and background. The poppies seem to push forward because they are red. The blue hills fade into the distance, and the sky also takes a back seat.

USING CONTRASTING COLORS

On the color wheel (*p.36*), each color is opposite another. Opposite pairs—red and green, blue and orange, yellow and purple—are called complementary colors. You cannot make red any redder, but you can make it seem brighter by putting it next to green. By using complementary colors together, you can make your drawings more vibrant.

Blue and orange

The kingfisher's plumage is made even more striking by the pairing of complementary blue and orange.

Red and green

A red rose looks even richer on its green stem. Nature's few high-intensity notes are all the stronger against the predominant greens and earth colors.

Yellow and purple

Yellow notes in the foreground leap out against the complementary purple of the mountains. The use of yellow in the sky and valleys unites the foreground, middle ground, and background.

Gallery

As much care has to go into choosing colors as arranging composition. Color is all the stronger for being applied with restraint and thought.

Trees by water ▶

Intense soft pastel color in the tree and patch of ground makes the foreground stand out. Notes of blue in the tree relate to the cool pale blue of the receding mountains across the lake. *Barry Freeman*

▼ Study of plants

In a largely monochrome drawing, the slightest hint of color can alter the mood. The addition of colored pencil lets a few buds and petals represent the delicate blooms of the many. *Lynne Misiewicz*

A dancer adjusting her leotard ▶

Against the mid-tone of the paper and streaked blue floor, the white and pink pastel shines out. Black outline contains the color and the skirting board counterbalances with darks. *Edgar Degas*

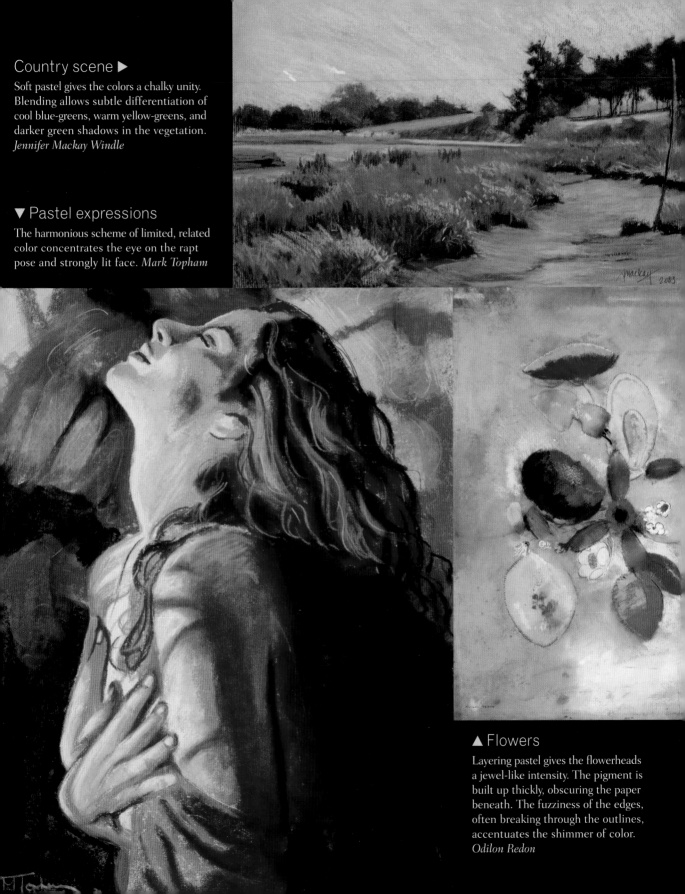

Country scene ▶

Soft pastel gives the colors a chalky unity. Blending allows subtle differentiation of cool blue-greens, warm yellow-greens, and darker green shadows in the vegetation. *Jennifer Mackay Windle*

▼ Pastel expressions

The harmonious scheme of limited, related color concentrates the eye on the rapt pose and strongly lit face. *Mark Topham*

▲ Flowers

Layering pastel gives the flowerheads a jewel-like intensity. The pigment is built up thickly, obscuring the paper beneath. The fuzziness of the edges, often breaking through the outlines, accentuates the shimmer of color. *Odilon Redon*

10 Exotic flower

Flowers provide an excellent opportunity to work with a truly vibrant palette. Here, a single flower head creates an explosion of color that almost fills the sheet of paper. Despite its impact, only a limited selection of oil pastels has been used. Oil pastel is a particularly flexible medium for colored drawing, as it can be applied in many ways to achieve different effects. One layer can be added to another. The layers can then be smudged and blended on the paper, or scratched and scraped through with a hobby blade or knife to define detail if necessary.

EQUIPMENT
- Mid-toned, textured pastel paper
- Willow charcoal stick
- Mid- and dark pink, orange, maroon, purple and deep purple, dark, bright, and pale green, black, bright blue, and deep red oil pastels
- Rag or facial tissue
- Hobby blade

TECHNIQUES
- Layering and blending
- Using bright color against dark
- Scraping back

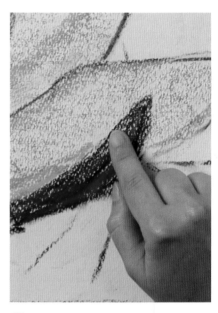

1 Sketch the outlines of the flower head in charcoal. You can draw boldly and make as many marks as you like because all the charcoal will be covered by oil pastel. Using the mid-pink oil pastel on its side, block in the background color of the petals.

2 Keep blocking in the largest areas of color over the whole flower head. Use orange as a second color over the mid-pink. Both of them are warm colors that seem to come forward. Cool blues applied later will stop them from vying for attention.

3 Use a darker shade of pink on the underside of the petals. To make this even darker, apply maroon pastel over the top of it and blend the two colors together with your finger. The main light and dark tones of the flower are now established.

BUILDING THE IMAGE

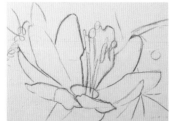
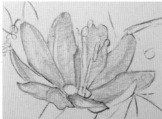
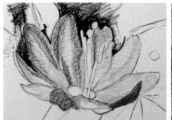

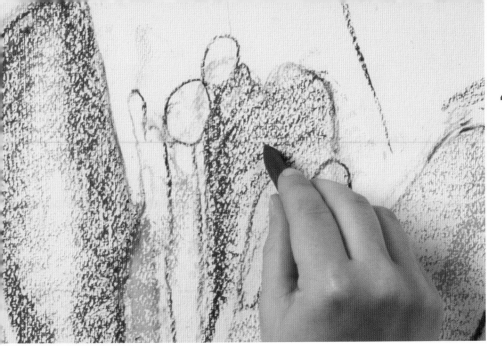

4 Begin applying a light layer of darker tone in purple, following the curved edges of the petals. Let the texture of the paper show through in places so that the colors really stand out.

PAPER WEIGHT

The best paper for oil pastel is relatively heavy, and should have enough tooth to withstand layers of color and scraping back.

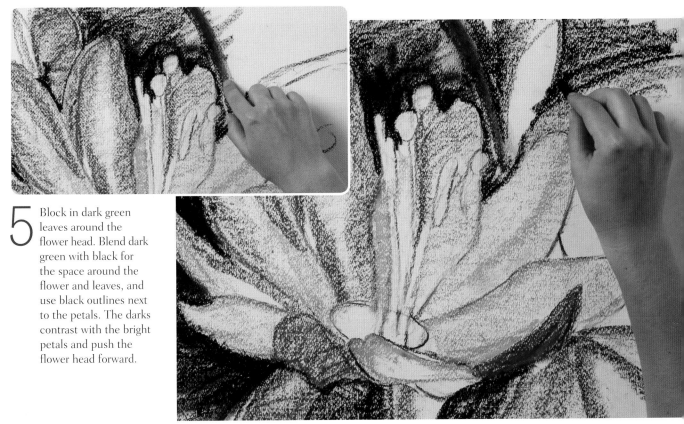

5 Block in dark green leaves around the flower head. Blend dark green with black for the space around the flower and leaves, and use black outlines next to the petals. The darks contrast with the bright petals and push the flower head forward.

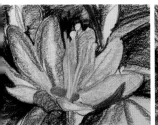 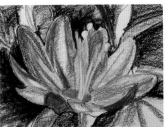 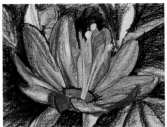 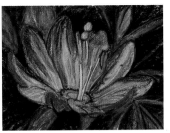

6 Returning to the inside of the flower, begin to add bright accents, using the point of the orange pastel for the tops of the stamens. Drive the pigment into the paper by pressing hard so that here you can't see the underlying texture of the surface.

"Oil pastel is heavy, so push and pull it to smudge it."

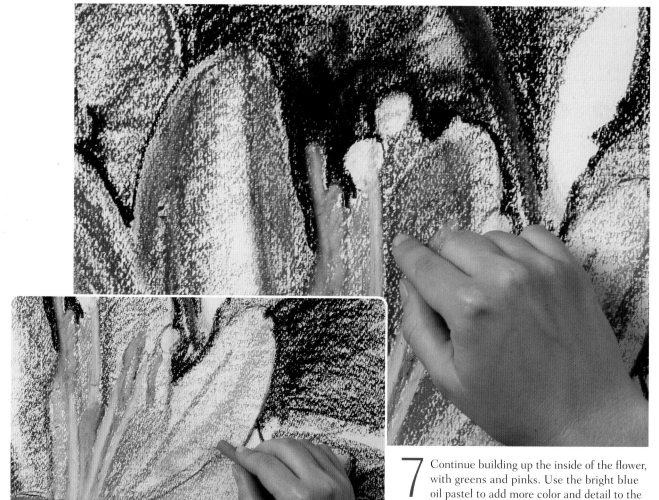

7 Continue building up the inside of the flower, with greens and pinks. Use the bright blue oil pastel to add more color and detail to the petals. Once you have laid down all the main colors, start to blend them together by gently rubbing them with your finger.

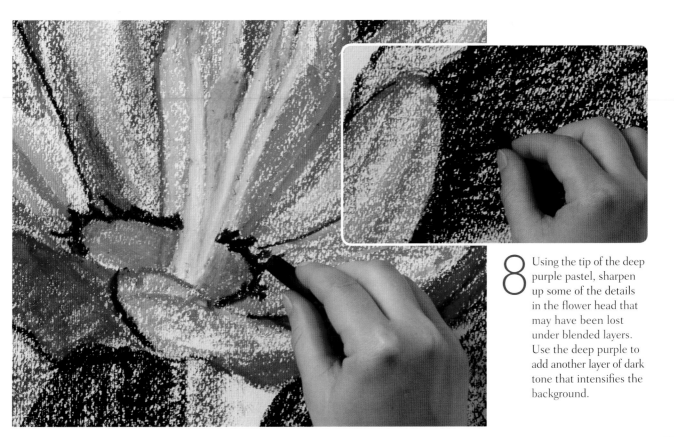

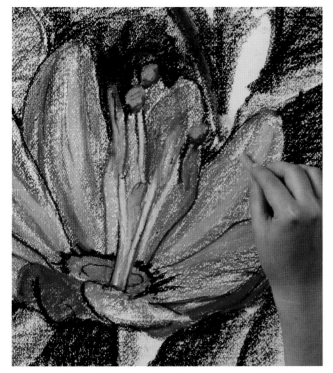

8 Using the tip of the deep purple pastel, sharpen up some of the details in the flower head that may have been lost under blended layers. Use the deep purple to add another layer of dark tone that intensifies the background.

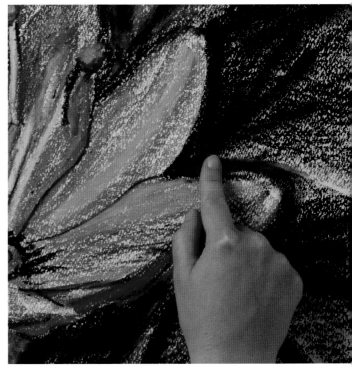

9 Using the ground colors as a guide, work up thicker layers by pressing harder with the oil pastels. Laying down more pigment strengthens the color, which increases the depth of the picture and the contrast between bright and dark.

10 Use the bright green over the top of the dark green ground on the leaves and blend the two together with your finger. The texture of the paper will begin to disappear as the oil pastel is pushed into its grain.

11 Blend larger areas of color together using a clean rag or paper towel. Blending creates areas of smooth texture and lifts off any excess oil color, so that you can add another layer of color if you want to.

12 Pick out the edges of the petals in deep red and blend them into the neighboring color with your finger. Wash your finger before you continue drawing or blending.

SCRAPING BACK

A hobby or craft knife is very useful for artists. If you have used many layers of oil pastel, you have to scrape back the pigment, being careful not to gouge the paper, before you can apply highlights. If not, the pastel will just slip over the top of the underlying layers.

13 Using the flat edge of a hobby blade, scrape back the layers of oil pastel to sharpen definition around the outlines of the petals. This will reveal the layers of color underneath and create bright linear marks.

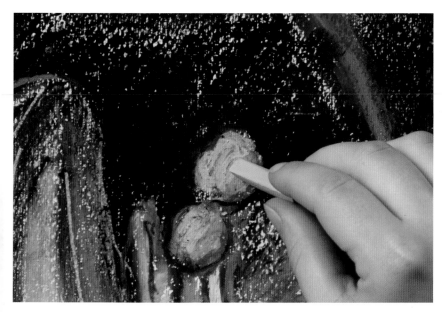

14 Lift some of the color off the green rounds of the stamens to get back to the paper. Add pale green to create highlights. Use dark green in the background around the stamens to create a contrast between dark and light.

▼ Exotic flower

Oil pastel works best with a confident, spontaneous approach. Here, it is the uninhibited use of color and boldness of composition that give this picture its dramatic visual impact.

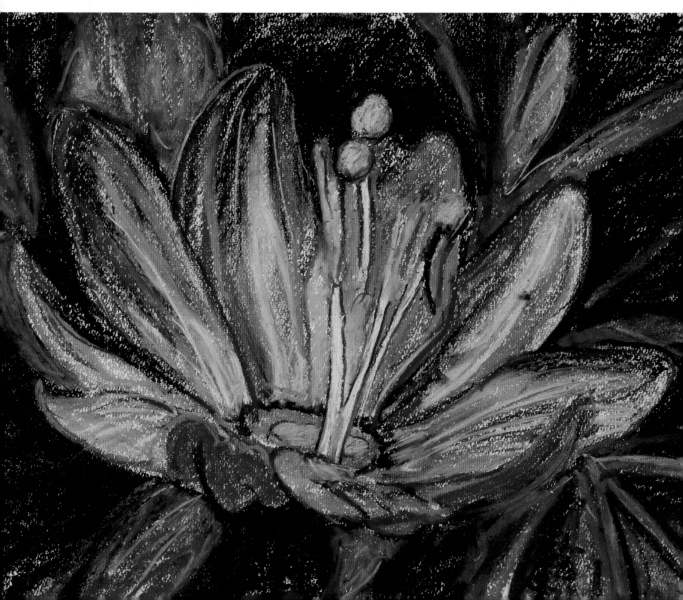

11 Market stall

When faced with an enticing array of colors and textures, as in this vegetable stall, it can be hard to know where to start, but this picture has been drawn quickly and decisively. Vigorous strokes of colored pencil in complementary colors have been juxtaposed with each other: red with green, and blue with orange. Colored pencil cannot be blended easily, so it has to be used in a linear way. Here, the pencil strokes are applied in many different directions to emphasize the contrasts in form and texture between the different vegetables.

EQUIPMENT
- 11 x 17 in Bristol paper
- 2B pencil
- Flesh, dark blue, orange, light green, dark green, burnt umber, light gray, dark gray, yellow, mid-brown, light red, dark red, dark plum, dark orange colored pencils

TECHNIQUES
- Juxtaposing complementary colors
- Crosshatching with two colors

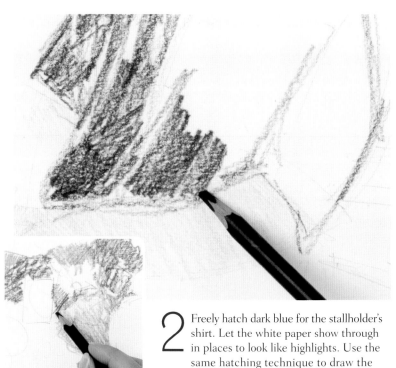

1 Lightly sketch the main features of the market stall and its background with the 2B pencil. Then start coloring in the stallholder's face and arms, using light diagonal strokes with the flesh pencil.

2 Freely hatch dark blue for the stallholder's shirt. Let the white paper show through in places to look like highlights. Use the same hatching technique to draw the vegetables: use orange for the carrots and the light and dark green for the broccoli, leeks, and lettuce.

BUILDING THE IMAGE

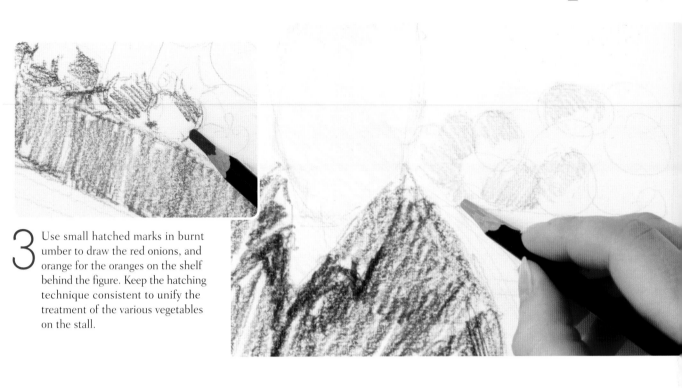

3 Use small hatched marks in burnt umber to draw the red onions, and orange for the oranges on the shelf behind the figure. Keep the hatching technique consistent to unify the treatment of the various vegetables on the stall.

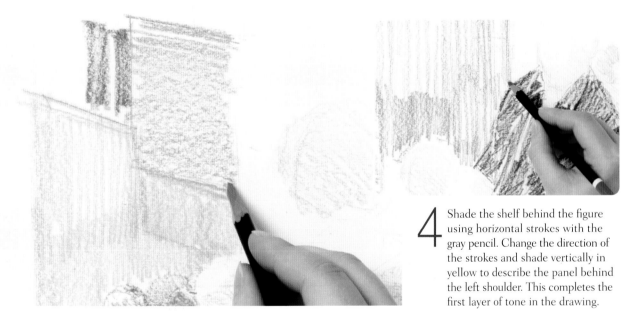

4 Shade the shelf behind the figure using horizontal strokes with the gray pencil. Change the direction of the strokes and shade vertically in yellow to describe the panel behind the left shoulder. This completes the first layer of tone in the drawing.

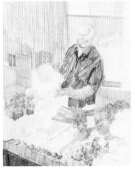
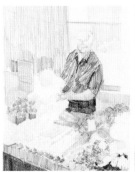
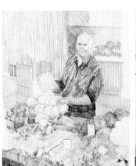
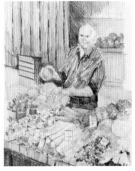

5 Begin the second layer of shading to introduce more detail to the scene. Using small, even strokes with the mid-brown pencil, add tone to the areas of shadow on the face. Layer the tone consistently across the drawing.

6 Crosshatch darker colors over lighter ones to define the shaded areas and shapes of the vegetables. Overlay brown with dark green in the right foreground, and dark over light red to contrast shadow and highlight on the radishes.

7 Add further definition to the face with dark gray, working up the eyebrows and the hollows of the eyes.

8 Use the dark plum color to add shadows to the radishes. Shade the underside of the oranges stacked behind the stallholder with the dark orange, letting the paper show through to create highlights.

9 Use broken lines of dark gray to suggest planks of wood. Strengthen the color with dark blue and brown.

Market stall ▶

In this picture, complementary colors are used next to each other, making them look more vibrant, and there is a lively contrast between the neutral tones of the background and the vivid vegetables in the foreground.

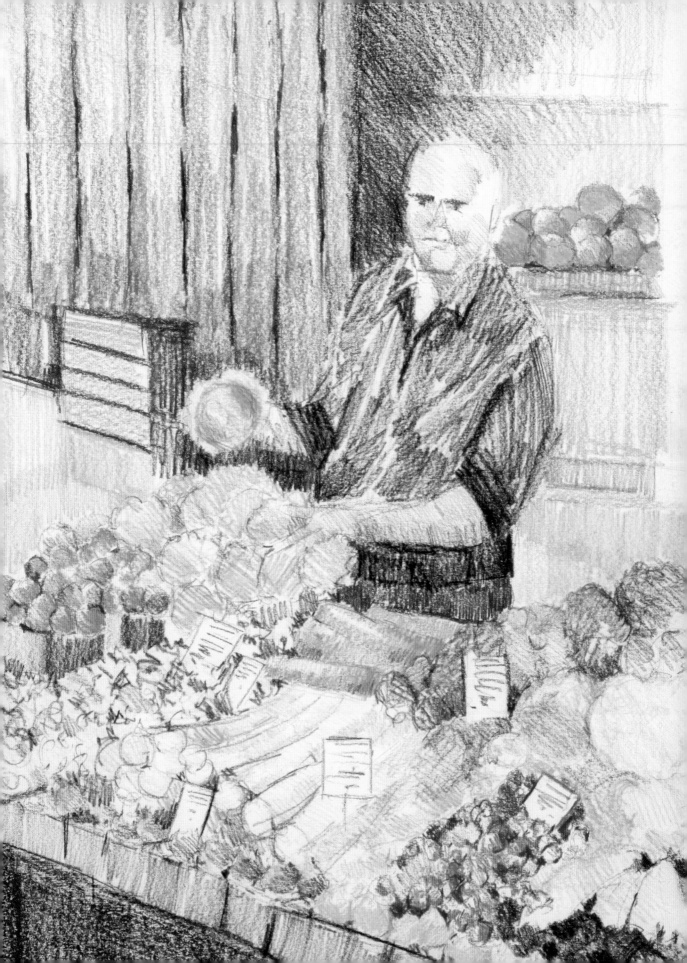

12 Girl on the beach

A vacation beach scene provides an excellent opportunity to work with vibrant colors in dazzling natural light. The bikini and beach mat provide vivid touches of color, and these are set against the softer earth tones of the girl's skin and the sand, and the pastels of the sea and sky. Soft chalk pastels are easy to blend, so you can create tone easily. Here, they have been used on dark paper to emphasize the brilliance of the colors and create a composition that captures the warmth of the afternoon and the glow of the sun as it sinks toward the horizon.

EQUIPMENT

- 11 x 17 in, dark-toned, textured pastel paper
- Pale pink and turquoise pastel pencils
- Raw umber, burnt sienna, light blue, bright green, raw sienna, dark purple, pale ultramarine, strong pink, light lilac, bright blue, mid-lilac, light orange, lime green, pea green, bright orange, pale pink, dark brown, turquoise, bright red, coral pink, dark blue chalk pastels

TECHNIQUES

- Blending pastels
- Juxtaposing bright and earth colors

1 Lightly sketch in the composition using the pale pink pastel pencil, taking the foreshortening into account. Loosely block in shadow, using raw umber for the ground and burnt sienna for the warmer dark tones on the figure.

2 Use light blue to draw the sea, pressing hard to cover the paper grain. Add a stripe of bright green below it where the sea meets the shore. Tone down the green with raw umber. Block in the sand and light skin tones with raw sienna.

BUILDING THE IMAGE

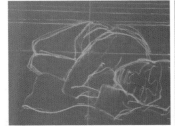
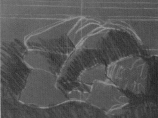
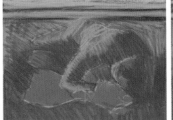
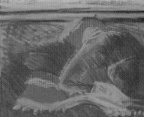

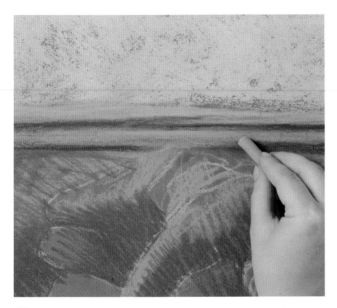

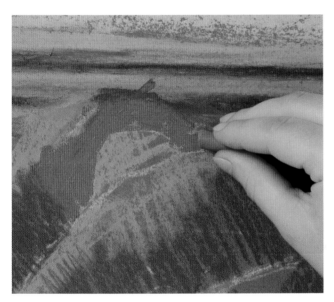

3 Add further detail to the sea where the waves break on the shore. Use dark purple to create lines of shadow set against a line of pale ultramarine to capture the rippled light effect on the surface of the water.

TONING DOWN BRIGHT COLORS

Using warm bright colors alongside deeper earth tones creates impact, but be careful not to overdo it. Any colors that look too strong can be toned down with a light layer of an earth color, such as raw sienna, blended or scumbled (thinly layered to create a veil) over the top. Repeating touches of the color elsewhere also helps to balance the overall composition.

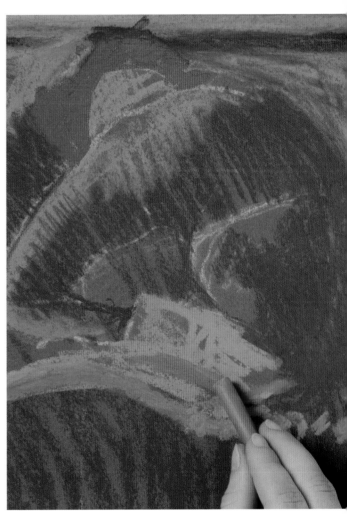

4 Using a very strong pink, boldly draw the girl's bikini, pressing hard with the tip of the pastel so that you cover the paper well. Just a small area of such a bright, hot color will stand out.

5 Use the same pink to add details to the beach mat. Add the light lilac. Over this, blend bright blue with pale ultramarine for the first stripe. Use two shades of lilac beneath the girl's head, the lighter one first.

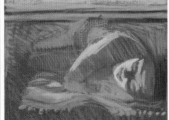
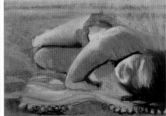
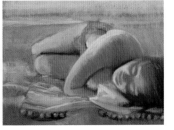

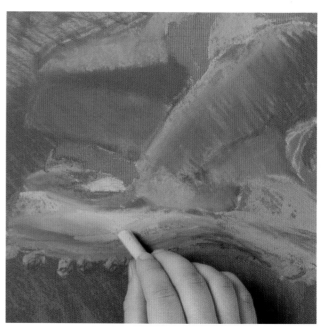

6 Use bright orange to add warm highlights to the exposed skin. Smudge the orange with your finger, following the line of the arm, and blend it into the layer of raw sienna below. Add the bright blue tassels on the mat.

7 Add more bright accents to the beach mat: light orange, and lime green blended over the top of pea green. Add a light layer of raw umber over the bright blue to tone down the color of the tasseled fringe.

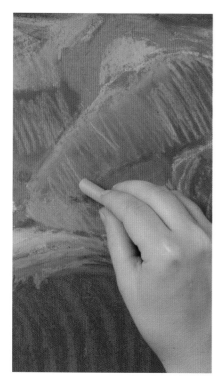

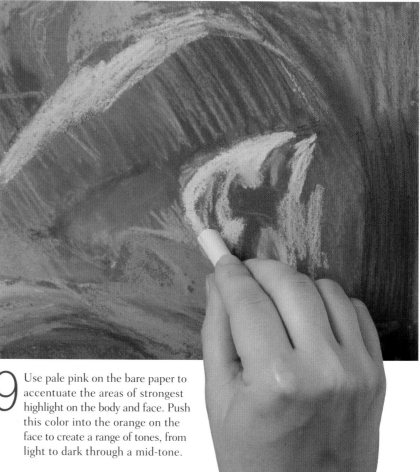

8 Lightly hatch lines over the girl's body and face with a bright orange pastel, to add warmth to the skin. Gently smudge the hatching lines with your finger to blend the colors in smoothly.

9 Use pale pink on the bare paper to accentuate the areas of strongest highlight on the body and face. Push this color into the orange on the face to create a range of tones, from light to dark through a mid-tone.

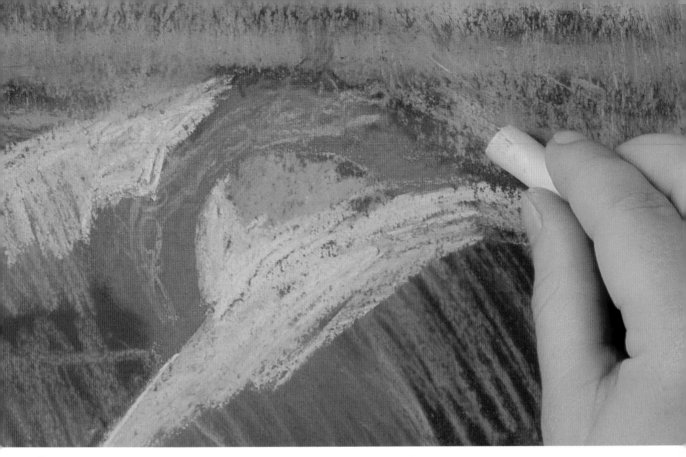

10 Scumble (*see p.38*) a veil of pale pink pastel over the background. Adding the paler tones here helps to create a sense of distance and links the pale tints in the drawing.

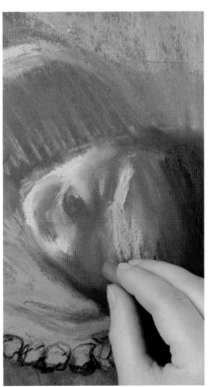

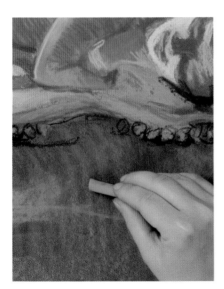

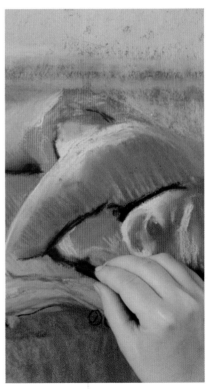

11 Add dark brown beneath the head and use it to outline and underline the tassels. Use raw sienna and turquoise on their sides to block in cooler tones in the foreground.

12 Create the glow of late afternoon sunlight by adding touches of bright red pastel around the eyes and mouth. This warm color brings the face forward visually.

13 Add definition to the body with the dark brown pastel. Smudge the line with your finger to blend it in and to soften the effect over the natural curves of the figure.

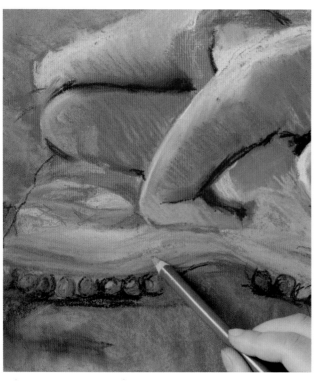

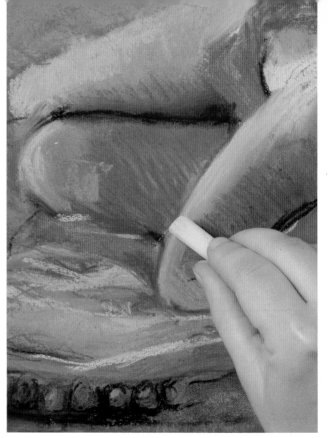

14 Use the turquoise pastel pencil to define areas of sharper detail that may have been lost under layers of blending. The pencil gives you more control and enables you to add detail without disturbing surrounding color.

15 Add some cool contrast to the skin tones with the same light blue as the base layer of the sea. Add highlights that contrast with the warmer areas of brown tone and suggest the reflective quality of the skin.

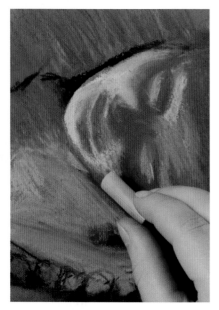

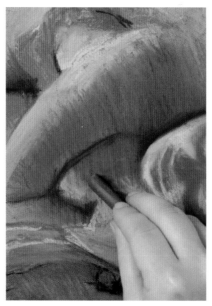

16 Tone down the red accents on the face with burnt umber, then stroke coral pink onto the face and upper arm. Keep checking back to the model so that you consider the overall effect when adding late details.

17 Tone down and soften the brown shadow lines between the arms with dark blue. Define the upper shoulder with raw sienna and dark blue scribbles. Bring the blue around the shoulder and onto the body.

18 Emphasize the highlight on the shoulder with the pale pink pastel. Use this color again to accentuate the lightest areas of sand in the foreground and background, harmonizing the overall tones of the drawing.

19 Add a final light layer of raw sienna over the foreground. Blend it in with gentle circular sweeps of the palm of your hand. Add some long, loose strokes of turquoise around the knees. This cool color will help to make the knees stand out against the background.

▼ Girl on the beach

This figure on a beach is an ideal subject in which to explore how to use color to create a sense of perspective. The cool blues and violets of the sea recede into the distance, while the rosy highlights on the girl's skin stand out as if in the foreground.

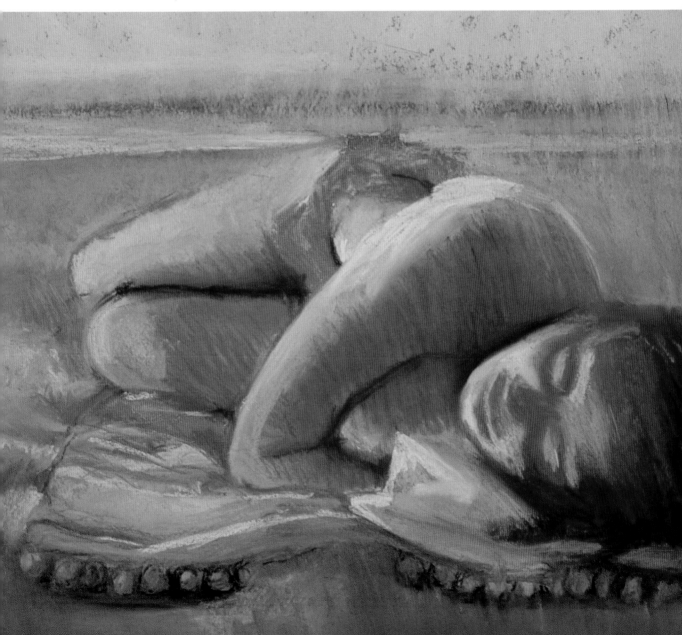

Glossary

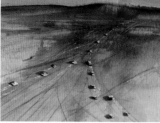

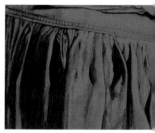

Aerial perspective
Where objects in the foreground appear darker, more detailed, and more focused than those in the background. In color, objects become bluer as well as hazier as they recede. Also called atmospheric perspective, and much used in landscape.

Binder
The wax in colored pencils, gum in soft pastels, and oil in oil pastels that sticks the particles of pigment together.

Blending
Mixing colors or tones on the paper surface so that they blur from one to another. The blending tool can be your finger, a shaper, paper stump, cotton swabs, cotton balls, facial tissue, a rag, or an eraser. Charcoal and pastel are good media for blending.

Brilliance
How bright or dull a color is.

Charcoal
Charred twigs or sticks such as willow. Good for free sketching rather than detail.

Color wheel
A visual device, much used by artists working in color media, which shows the relationships between different colors.

Colored pencil
Wax-based crayons in pencil form. Available in a wide range of colors and good for colored linear drawing.

Complementary color
Colors opposite each other on the color wheel: yellow and purple, red and green, blue and orange. Complementary colors used next to each other in a drawing create contrast and appear to make each other look brighter.

Composition
The arrangement of elements and spaces in a drawing to create a harmonious whole.

Conté crayon
Midway between hard and soft pastels and based on chalk. Available in square sticks and pencil format.

Contour line drawing
Outline drawing without the use of tone.

Cool color
Blue and colors on the blue side of the color wheel, which appear to recede from the viewer.

Crosshatching
Crisscrossing parallel lines to create tone. The closer the lines, the denser the tone. A good technique in linear media such as pencil and pen. In colored pencil, crosshatching two colors can create an optical blend.

Ellipse
The oval formed by a circle flattened in perspective.

Eye level
The imaginary line running horizontally across the picture where your eye level is. In

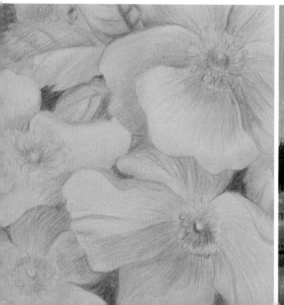

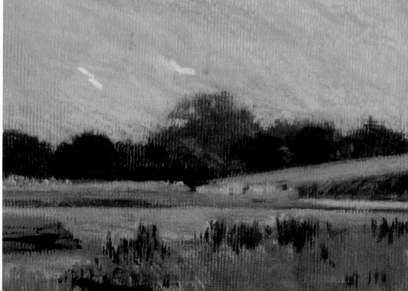

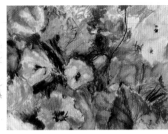
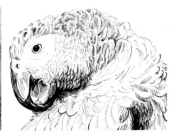

perspective, horizontal lines above it appear to slope down, while horizontal lines below it appear to slope up. They converge at your eye level.

Fixative
Liquid resin spray or atomizer. It glues easily smudged media such as charcoal and pastel to the paper. Fixative should be applied outdoors, or at least in a well-ventilated room, in a light, continuous motion from top to bottom of a drawing held vertically, at a distance of about 12 in (30 cm). Hairspray is an alternative.

Focal point
The part of a composition that holds greatest interest and instantly attracts attention.

Foreshortening
The effect of perspective that makes forms appear to get smaller with distance, particularly noticeable in figure drawing, when it distorts the proportions of the body. Applying foreshortening helps make objects look three dimensional on the flat drawing surface.

Form
A shape drawn to look three dimensional, often with the use of tone.

Format
The size and shape of the drawing surface, usually rectangular or square. A tall rectangle is known as portrait format; a wide rectangle is known as landscape format.

Graphite
The carbon-clay mix used in pencils. Graphite sticks are pure graphite without the wooden casing.

Hatching
Parallel lines for shading. If the hatching curves, following the form of the object, it is called bracelet shading.

Highlight
The most brightly lit spot on an object.

Horizon line
In linear perspective, the imaginary line at your eye level, where horizontal lines converge to a vanishing point. The true horizon line, where land meets sky, may be higher or lower than your eye level.

Leading line
A line that entices the viewer's gaze into the picture. It may be a path, a road, or something less tangible, such as a shadow or a reflection.

Lifting out
Using an eraser to draw highlights out of dark tone in a charcoal or pencil drawing on white paper. The technique uses the eraser as a positive drawing tool rather than just to rub out mistakes.

Linear perspective
A method of portraying three dimensions on a flat surface by showing how parallel lines, for example, of a road or railroad track, appear to converge in the distance.

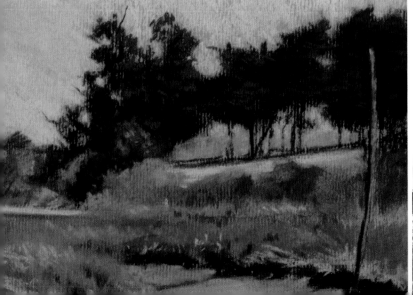

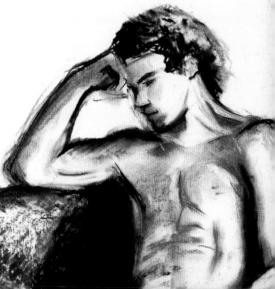

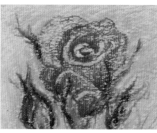
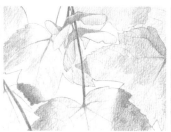
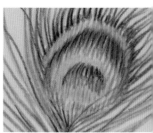

Medium (Media)
The drawing material, such as charcoal, pen, pencil, or pastel

Modeling
Using light and dark tone to give a three-dimensional impression. Also refers to a person posing for a portrait or figure study.

Monochrome
Working in black and white and shades of gray, for instance, in charcoal or pencil drawings, or working in any single color.

Negative space
The gaps between objects. Negative space is as important as positive form in creating a satisfying composition. Drawing the boundaries of negative space is often more successful than drawing named objects, as it encourages close observation.

One-point perspective
In linear perspective, parallel lines are at right angles to the picture plane and meet at a vanishing point on the horizon.

Pastel
A color drawing medium in which powdered pigments are bound with gum into sticks. Soft pastels, often called chalk pastels, are powdery. Conté crayons are harder. Both come in pencil form. Oil pastels are sticky and closer to painting media. A drawing made with pastels is called a pastel.

Perspective
A drawing made in perspective looks like a vision of the real, three-dimensional world through the use of modeling, linear and aerial perspective, and foreshortening.

Picture plane
The flat surface of the picture as if transparent, held parallel to the artist's face, depicting imaginary space. It is best visualized as a glass pane with the drawing pressed onto it.

Pigment
The coloring agent used in pastels, colored pencils, and all paints. Nowadays most pigments are synthetic.

Positive shape
The outline shape created by an object.

Primary color
The three colors that cannot be mixed from others: red, yellow, and blue.

Related color
Colors near each other on the color wheel, such as yellow and orange, which harmonize when used together in a composition.

Rule of thirds
Compositional guidelines by which the drawing surface is divided into thirds to form a nine-square grid. The focal point or points are placed on one or more of the intersections for maximum visual effect. The rule is especially useful when composing landscapes.

Secondary color
Colors mixed from any two primary colors. The three secondary colors are orange (from red and yellow), green (from yellow and blue), and purple (from blue and red).

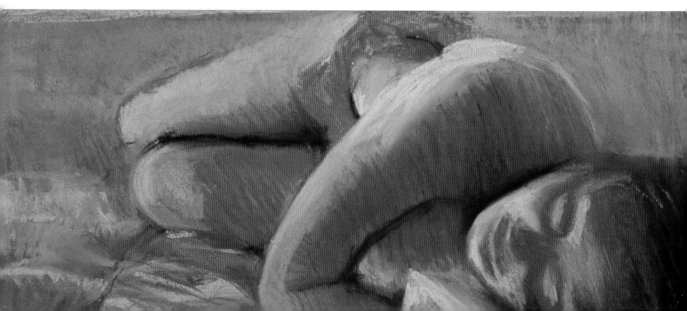

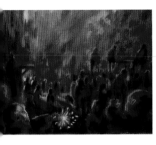 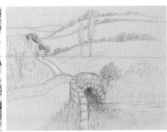

Shading
The application of tone to a drawing, for instance by varying the pressure of a charcoal stick, to give a three-dimensional impression.

Shadow
The darkness cast when light is obscured, either on an object or by it.

Sighting
Using a pencil to measure relative sizes and so draw objects in correct proportion to each other. It is important to keep the arm straight, the head still, and one eye closed for consistent measurements that mimic the single viewpoint of the drawing. The same method of holding up the pencil can be used to assess angles against horizontal or vertical lines.

Stippling
Using dots rather than lines or continuous tone to create shading. Stippling is a useful technique for linear media such as pen and ink.

Support
The working surface, usually paper, for a drawing.

Technical pen
A disposable pen with an inflexible nib that produces a consistent line regardless of pressure. Technical pens are measured by the width of the nib in millimeters. Used by architects, engineers, and artists.

Tooth
The raised grain of textured paper, which bites into the medium applied to it. Powdery media such as charcoal or soft pastel need paper with a tooth to stick to the surface.

Tone
From white to black, how light or dark something is, regardless of its color. Some colors are inherently light or dark in tone: yellow, for example, is always light.

Two-point perspective
In linear perspective, an object such as a building has vertical edges parallel to the picture plane but its sides are seen at angles. The horizontal lines of the sides appear to converge at two separate vanishing points on the eye-level horizon line.

Vanishing point
In linear perspective, the point where receding parallel lines appear to converge.

Viewfinder
A framing device to help decide on a compositional view. Two L-shaped pieces of black cardboard can be held together in any format to see how a given scene would look on paper.

Viewpoint
The position from which the artist sees and draws subject matter. As well as moving from side to side, raising or lowering the eye level creates a different viewpoint.

Volume
The bulk of an object, its three-dimensional solidity.

Warm color
Red and colors on the red side of the color wheel, which appear to advance toward the viewer.

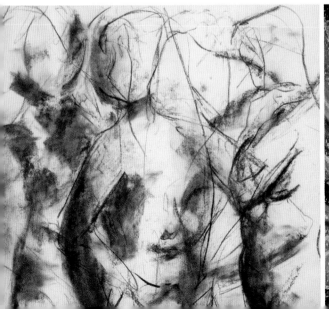 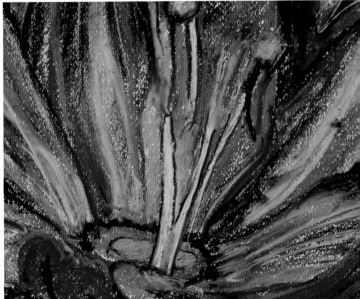

Index

Acknowledgments

PUBLISHER'S ACKNOWLEDGMENTS

Dorling Kindersley would like to thank: Murdo Culver, Mandy Earey, Katie Eke, Karla Jennings, Simon Murrell, Lee Riches, and Rachael Smith for design help; Caroline Hunt for proofreading; Dorothy Frame for compiling the index; Lesley Grayson for picture research; Simon Daley for jacket series style; Ian Garlick for jacket photography; Sharon Spencer for jacket design; Amber Tokeley for jacket editing; Monica Pal for administrative support; Jamie Brugos for modeling; Jenny Siklós for Americanization.

DRAWING CREDITS

Key: t=top, b=bottom, l=left, r=right, c=centre

p.2: Lindi Kirwin; *p.28:* Lucy Watson; *p.29:* Lynne Misiewicz; *p.32:* Bryan Scott; *p.33:* Lucy Watson (r); *p.35:* Lucy Watson (b); *p.44:* Copyright © Christie's Images Ltd (tr); © Alinari Archives/CORBIS (br); *p.45:* © Franklin McMahon/CORBIS (b); *pp.46-49:* Rosie Morgan; *pp.50-53:* Lynne Misiewicz; *pp.54-57:* Liane Holey; *p.61:* Lucy Watson (b); *p.62:* © Albright-Knox Art Gallery/CORBIS (b); *p.63:* Copyright © Christie's Images Ltd (br); *pp.64-67:* Lynne Misiewicz; *pp.68-73:* Anita Taylor; *pp.74-79* Lynne Misiewicz; *p.84* © The Art Archive/University of Wesleyan Middletown USA/Album/Joseph Martin (t); *p.85:* © Burstein Collection/CORBIS (t), © Historical Picture Archive/CORBIS (bl), © The Art Archive (br); *pp.86-89:* Mark Topham; *pp.90-93:* Barry Freeman; *pp.94-99:* Rosie Morgan; *p.104:* Copyright © Christie's Images Ltd (br); *p.105:* © Christie's Images/CORBIS (cr); *pp.106-111:* Mark Topham; *pp.112-115:* Barry Freeman; *pp.116-121:* Ruth Geldard.

All jacket images © Dorling Kindersley.